# TALES OF THE LEAP

A girl born in WW II growing to a woman and finding
a better life if brave enough to take the leap

by

## TATJANA WEBSTER, MD

**TELEMACHUS PRESS**

TALES OF THE LEAP

Cover designed by Telemachus Press, LLC

Cover art and interior photos used with permission

Published by Telemachus Press, LLC
7652 Sawmill Road
Suite 304
Dublin, Ohio 43016
http://www.telemachuspress.com

Visit the author website:
http://www.uknleap.com

ISBN: 978-1-948046-27-5 (eBook)
ISBN: 978-1-948046-28-2 (Paperback)

Library of Congress Location Number: 2018910825

Version 2018.11.12

# TABLE OF CONTENTS

# ACKNOWLEDGEMENTS

I would like to acknowledge people who believed in me even before I believed in myself. A special thanks to editors Dr. Karen Lieberman and Ms. Michel Hammond, business manager Ms. MaryAnn Nocco and Mr. Steven Himes who pushed my project forward. The artistic work of Johnny Breeze captured the voice of my book on the cover. Great thanks to my brother Mirko who encouraged me to travel to Yugoslavia after more than 50 years living away and helped me to fill in so many forgotten details.

I am very grateful for the valuable suggestions at the beginning of my writing from my niece Sandra and her husband Paul. I want to thank my cousins Arsen and Sasa for long phone conversations about the years in Split before and after I was born.

I am profoundly grateful for the loving support and critical suggestions of my husband Webster. I couldn't have done it without you.

*Dedicated to my family, past and future.*

# TALES OF THE LEAP

A girl born in WW II growing to a woman and finding
a better life if brave enough to take the leap

# TALES OF THE LEAP

*I found my path in the roar of the North Sea,*
*I found my leaps in the mist of English fog,*
*I found my leaps in the winter of the North,*
*I found my leaps in the country of a new dawn.*

*Sometimes, I felt abandoned, alone in the New World,*
*sometimes I was led by my faith,*
*sometimes I doubted my search for unknowns,*
*sometimes I would err,*
*sometimes I walked blindly,*
*without spoken words of my desire.*

*Many times I asked the sky,*
*to help me enter the world of my desire,*
*to help me find leaps in unknowns,*
*to open flowers of the home*
*to open gates of my inner self.*

*I will honor you,*
*I will honor you with remembrance of your soul,*
*I will honor you with your words,*
*turn the page and go forward.*

Tatjana Webster, St Petersburg
January 2016

# INTRODUCTION

D RIVING IN MY car, listening to the music of Dvořák and
Sibelius, brings my thoughts back to Yugoslavia and
Sweden. Music opens the door to memories, and at this moment
my past is an erupting volcano with fleeting images flying about,
causing an emptiness inside me and chaos in my universe.

I am a person who thinks her life runs at full speed, leaping
into unknowns and finding accomplishments, adventure, love
and trust. Each leap has touched and changed my life, and today,
as I write, I begin to see they were all interconnected; maybe I
was not aware at the time, perhaps simply not allowing myself
understanding. I've learned from my leaps, bringing my heart to
heights of happiness and contentment that were never expected.

These tales are my memories, beginning in Europe during
World War II. My wish is to share with you the joyful moments
and sorrows that are common to all people and to explore the
question that confronts us all: Dare I go forward on my journey
with leaps into the unknown?

# CHAPTER ONE

MAMA, PAPA, AND Noné Pina all lived in Split, capital of the Croatian region of Dalmatia, on the coast of the Adriatic Sea. My widowed grandmother, Noné Pina, lived with her daughter, Ksemida, who was later to become my mother. Dragan, later to become my father, was stationed in Split as the ranking officer in the King's Cavalry and rented a room in Noné Pina's home. They went about their normal lives for about two years until the Axis armies invaded the Balkans at the start of World War II. My soon-to-be family knew that the Nazis were no friends of theirs, and my father was a target because of his military rank.

There are stories that never left me. During the war years, the people heard sirens; then they would hide, usually in the basement. They listened for the sounds of enemy boots on the streets. They all felt fear because death was an everyday event.

The King's army had capitulated and was in total disarray, and the three of them made plans to flee Split by way of the

Macedonian Republic into Bulgaria. They boarded a blacked-out night train as bombs rained on the city in front of the advancing Axis armies. Papa's family had property in Macedonia outside of Skoplje where they stayed for some time. Mama and Papa were married in Macedonia, and two years later, in April, in the middle of the war, I was born. The Macedonian political strife increased with different factions taking control, and the family had to escape again.

They arrived safely in Sofia, the capital of Bulgaria, certainly with their hearts full of both dread and hope. Considering the political situation, the family decided to change their Serbian name. Because of Papa's rank in the King's Cavalry he was in danger, both during and after the war, from the invading armies and later the partisan communists. He had the presence of mind to change his last name in order to survive. We were saved because of the name change, adopting its Bulgarian form, and because we left Yugoslavia for a while. The politics of the old country, initially led by the King and then occupied by the Axis armies, was treacherous. Also, many local factions formed with the partisans, led by Tito and the Communist Party, eventually emerged as dominant after securing backing from the U.S. and its allies.

We lived in Bulgaria temporarily, with my only memories being large fields of red roses and the shining gold of the church in Sofia. As the war and local conflicts in Yugoslavia wound down, we made our way back to Skoplje, Macedonia, where we had lived before our journey had taken us onward. My brother

Mirko was born there, and a short time after his birth my family left for a new life in Belgrade, the capital of Yugoslavia.

We survived the war, living on soil where we were not able to put down roots. We lived without being fully accepted by the people around us. My parents were from different regions of Yugoslavia, different religions and we now had a foreign last name. Rejection was our personal prison; our emotions were buried deep inside us. At the same time, looking back to that period of our lives, not having roots helped us to move forward faster than others.

At that point, our family was making its way through turbulent waters and political turmoil. Noné Pina's life would never be the same. Mama was a young mother, and Papa's former military career was no more. Noné Pina's family had left Dalmatia for Italy and South America, and some of them were never to return. We went where the wind blew us, but always with a careful plan for survival, as I now realize.

While I write about these memories, I look at a small, faded photograph of me in Mama's arms and covered with a white blanket, a baby barely able to keep her eyes open. The bright, early spring sun is shining on the surrounding tree branches, with patches of white left from the last snow. Another picture shows Mama, Papa and me as a baby; Papa was holding us together. Even then, the enormous love my parents had for me through very difficult circumstances was obvious.

Memories of these stormy years were buried deep inside, and as I grew in years, I hoped they would not affect me later in life. Would this early period of my life bring fear and insecurity,

longings that could not be understood or fulfilled? I hoped that they would stay buried and never come back. Maybe they would give me strength when adversity came, as it surely would.

# CHAPTER TWO

DURING THE DECADE after World War II, we were surrounded by misery mixed with optimism for a peaceful future and the effort to rebuild. My upbringing was strict, our values concrete. The daily search for basic survival was constant. My parents gave me a strong foundation, and for my part, I learned to study and to achieve my personal goals through hard work.

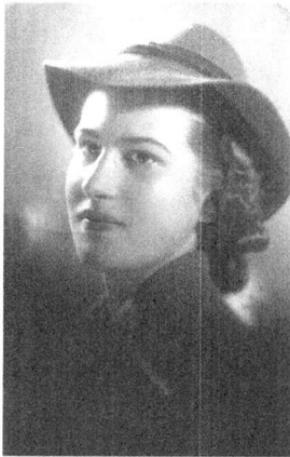

*Mama, one of the most beautiful women in Split: Dalmatia, 1939.*

I had no better example than my Mama. She was a beautiful, tall woman with brown hair, dark brown eyes, and a lovely warm smile. I knew her as a very intuitive, sensitive and strong person, facing reality straight on, no matter how unpleasant or difficult it may be. Mama was quite intelligent; later in life, even in her 90s, she delighted in the stories and poems that she had learned in school. She expressed herself very well in words, but her forte was mathematics. She kept our household and business budgets and could add a column of numbers at a glance; during her later years she learned Swedish, adding to the Serbo-Croatian, French and Italian that she already knew.

My Mama loved to laugh. She loved to swim, and she would plunge into the sea every chance she could, right up until the end of her life. Mama loved music, fast and slow, modern and classical, and sometimes later there would even be hip-hop playing on her radio. Mama was always very kind, putting the feelings and needs of others before her own with a deep, ever-present warmth and family devotion, which overshadowed all of the harshness and difficulties we faced in Yugoslavia during and after the war.

She would get up at four o'clock in the morning to go to the open-air market, and in the winter she would walk through the snow with the cold winds blowing just to be first in line to buy food before it was gone. She would come back home before we were even awake to start preparations for the evening dinner, and then she would go to work. For more than 25 years, my Mama worked at an office in the Albania Palace building, which stood prominently in the north end of Belgrade. This was the

first multi-story building in the city, completed in 1939. It took the name of the small café that it replaced, the Albania Café. We called it the skyscraper.

Mama had an enormous zest for life, and she possessed both the physical and psychological strength necessary to overcome any obstacles. After work, Mama would return home almost at the same time as Papa, and when the food was ready, all of us including my grandmother, Noné Pina, sat down at the table to eat. I remember that conversation was not our family's strong side. You talked if you had something important to say. The adults discussed daily events, and the children listened.

# CHAPTER THREE

I HAD A fear of darkness when I was a child. My imagination flew and I used to tell myself stories looking through the window at the sky. Clouds constantly changed their forms. Sometimes I thought the clouds were looking down at me, a little girl with stars in her eyes, wrapped tightly up to her chin in her bedspread. I imagined the clouds forming the shapes of big animals that would take me away. My heart was pounding when clouds moved closer. Mama would come to my room when I was afraid, and many nights she would sit next to my bed telling me stories until I fell asleep.

Mama would say, "You see clouds coming and going. Some of them are very fast and some slow. Imagine you are in the forest now, looking toward the sky with branches of trees moving in the wind. Imagine branches having many leaves, some with bird nests. You can hear the baby birds chirping, waiting for parents to bring them food. Imagine green and blue colors of nature so beautiful." Slowly her voice would lead me to a world of twilight and dreams. Fear would disappear. Peace was inside

and around me. I loved to hear her stories about the bird's life. Other times, when I was scared hearing a thunderstorm with wind blowing the rain, Mama would tell me a story: "I know you are scared, try to think about rain drops coming from clouds. After the sun comes, each raindrop will have many colors from the bright sunshine. All those colors will make a beautiful rainbow under which you sleep." I would listen, close my eyes and enter my dream world.

I don't remember if my brother was ever afraid. One night there was a violent thunderstorm, and Mama came and held me until I felt safe. Mirko held his blanket tight, closed his eyes and fell asleep. In the morning, Noné asked, "What was all that non-sense going on last night?" The three of us smiled mischievously and just kept our secrets to ourselves. We both found safety in Mama's arms, listening to her soft voice telling us stories with the same closeness she later had with her granddaughters.

When I grew up in Yugoslavia, celebrating Christmas was forbidden, as it was in most Communist countries. In our home, out of the sight of others, on Christmas Eve we waited for Papa, who would sneak in the Yule log he had bought in the open market. It was called *Badnjak* and was made of oak branches together with a small bundle of wheat. Papa would place our *Badnjak* in the corner of our living room on a box covered with red cloth. On the floor around the box, and on top under the *Badnjak*, was a layer of straw, like the stable where Jesus was born. The dry golden brown star-shaped leaves gave off a fragrance of forest and peace at the same time. To me, the leaves looked like birds coming in from the harshness of the cold

winter day. Every year, our celebration gave us a feeling of togetherness as a family. Before dinner, the children would take small pieces of neatly folded paper on which we had written our wishes, and lay them on the straw under the *Badnjak* tree. Mine read, "I wish for peace everywhere. I wish that my parents will live forever."

Then, it was time for our *Badnje vece* dinner. A white cloth covered the table and in the center was an evergreen wreath representing eternal life. Four red candles were set in a circle, a symbol of the four advents. Papa would light these candles as we sat down to dinner. A white candle in the center was lit on Christmas Day.

At Christmas time the smells of baking, cooking, and evergreen filled our home. For *Badnje vece* dinner, we had grilled fish and smoked seafood; calamari and shrimp; a stuffed goose; potatoes and vegetables. First we had a moment of silent prayer, and then we sat together to eat, surrounded by family and the warm glow of candles. After dinner, dessert and fruit were served: a baked cake with several layers of chocolate and dry plums, figs and apricots. As I write, the smell and taste of *Badnje vece* comes back to me even now. Afterward, we waited excitedly for *česnica*, a round sweet bread that Mama and Noné baked with a coin inside. Each of us would break off a piece hoping to find the coin. Whoever got the coin would have good fortune for the coming year. I never got the coin.

After *Badnje vece* dinner, Papa would place the *Badnjak* outside on our balcony instead of burning it, as was tradition, because we didn't have a fireplace. Our wishes written on small

pieces of paper were still on the straw beneath. After a few days, our papers with wishes disappeared along with the straw.

On Christmas Day, *Bozic*, our neighbors and my family would greet each other with: "Christ is born" *Hristos se rodi*. On that morning we would light the white candle in the center of the evergreen wreath and wait for the dinner that Mama and Noné had prepared. The table filled with pork roast, potatoes, *sarma* (stuffed cabbage leaves with ground meat and rice), vegetable pies, homemade *ajvar*, sauerkraut, pickles and noodles with minced walnuts and brown sugar. I fondly think about those days so full of happiness and togetherness.

Mirko and I were told never to mention to anybody that we celebrated Christmas. Now, many, many years later, this picture of us as a family bound by invisible threads of togetherness is a strong reminder of the power of our love. Today I look at our photos taken years later at Christmas in Sweden and America, and I have feelings of achievement, happiness and celebration. I also have some sadness remembering those early years of our childhood in the old homeland where the secret celebration of Christmas was a part of our way of life.

# CHAPTER FOUR

OTHERS CALLED HIM Dragan, but to me he was always just Papa.

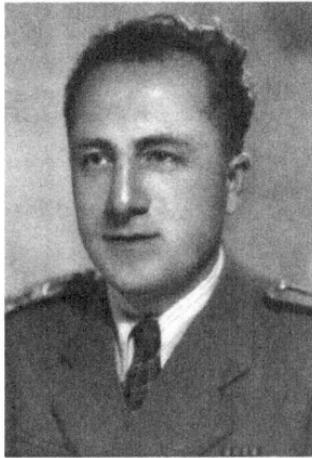

*Papa, a young officer in Split, Dalmatia, 1938*

He was of medium height, muscular, with curly, brown reddish hair, gray eyes flecked with green, a somewhat stern countenance and military bearing on the outside, but with a

warm and giving heart inside. In 1937, Papa was assigned to the coastal city of Split, in Dalmatia, and his life was destined for change when he met Mama. She was seventeen and he was twenty-nine. They were married in 1941, and later, after the war, when they finally made it to Belgrade, they started building a new life as a family. In addition to his daily job at an international business bank, Narodna Banka, he took courses at the University of Belgrade and graduated from the Faculty of Economic Sciences.

In my memories, Papa was always dressed in a dark suit, white shirt and dark necktie, always with a dark hat and a long overcoat in winter. He worked every day in the bank, and when he had free time he was busy with volunteer work. The former military reserve officers would meet in the community centers and work on projects for collecting clothes and other household necessities for unfortunate families like those that lost everything during the war. Papa worked with blood drives, was a donor and received an award that I cherish as a beautiful memory. The recognition Papa received for his community service enabled our family to attain a certain status in the political climate we lived with.

Sometimes, during the spring and summer months, on weekends, Papa would go to the nearby park to play chess, and once he won a chess competition against a high ranked player. I still see him sitting in the park with the other chess players on the bench under a large and ancient chestnut tree. He brought birdseed to the park, and scattered it around for the many gray doves strutting about his feet.

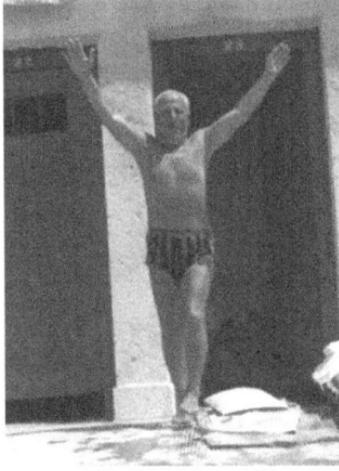

*Papa often said, "In sanctum corpus, sanctum spiritus"*
*before jumping in the water.*

Papa loved to swim, and when he dove in the water, he would almost always first say, "In sanctum corpus, sanctum spiritus," which means, "in healthy body, healthy spirit." I do not remember him ever being sick. Later in life, I would remember Papa's strength and intelligence, his progress in life and his many achievements and accomplishments, which he acknowledged with humility.

My brother and I grew up in a family that shared strong bonds of love and respect. Mama and Papa had a secret language; they could communicate with just a look. I understood that this came from a deep love shared between them. Papa also liked to surprise his family. He often came home with his hands full of chocolate for Mama, candies for us children and flowers for Noné.

The children at school benefited greatly from Papa's talent for drawing. In the post-war times, many necessities at the school were missing, and talented people like my Papa contributed to our education. I remember him making illustrations of animals, insects and plants for the biology classes. Teachers and students loved these colorful illustrations. I often wonder now what he would have told me about those times if he had still been with me.

In addition to his artistic skills, Papa was a mathematician and was skilled with the written word. I now realize that his education at the military academy would have qualified him as an engineer in the United States. I recall that I admired his calligraphic handwriting, but unfortunately, I did not inherit that skill. He showed us affection without many words or gestures. Still, I could feel his deep love toward me.

I remember Papa carrying me on his shoulders in the park where there were ponies. One day, I wanted to ride, but Papa knew I was afraid of the animal's power. I recall him saying, "Ride only if you can feel a connection with the horse. If you are afraid of the pony, he will be afraid of you." Our time flew fast that afternoon; the day was beautiful, with the branches of the green, tall trees in the surrounding forest moving slowly in the warm breeze, the grass scattered with yellow flowers. I remember how safe I felt on my Papa's shoulders. It gave me a feeling of flying high in the air. After a while, Papa sat me on the back of the pony and we somehow connected, or maybe both the pony and I were afraid of disturbing the harmony of the moment.

Both of my parents instilled in me deep feelings of generosity, patience and a belief in myself. I learned that Papa had always wanted me to become a doctor, even though I don't remember either of my parents ever saying this. Much later, I found this wish, written long ago, among some of his papers. I cherish every word, and I keep it in my private box as one of my most precious gifts. As I look back, recalling events that have shaped my life, it is now clear Papa's guidance had shown me the way.

# CHAPTER FIVE

IN BELGRADE, OUR family lived in a five-floor apartment building on a street named "The Boulevard of the Revolution." Today, it is called "The Boulevard of King Alexander." This street was, and still is, one of the longest in Belgrade, and it follows the line of the ancient *Via Militaris*, the road that led to Constantinople. A student dormitory was located close to our building, and nearby was the park where Papa played chess. The university library, the schools of civil and electrical engineering, and the Faculty of Architecture buildings were also located on our street. Just beyond those, the descending steps from the street led to the elegant *Vukov Spomenik*, a monument dedicated to one of the most prominent figures in modern Serbian history and culture. I loved that sculpture and passed it almost every day, sometimes several times a day, and always took a moment to study its form and artistry.

In Belgrade, I had a close girlfriend named Mira who lived on the third floor. One day, she knocked at the door of our

apartment. She said to Noné Pina, "Where is Tanya? I need to tell her something very important." At the time, we were ten or eleven years old. Noné called me and Mira said, "Today we will name our dolls. They need to have nice dresses." We searched Noné's sewing area, but couldn't find any scraps of old material to cover them, so we decided to take newspaper for our dress-making. We walked together to the balcony, carrying our treasures in kitchen matchboxes, and there we had a small ceremony. We placed the dolls in their paper dresses under a blooming rose bush, and with very serious faces, gave them names. My doll was named Rose and hers was Lilly. These years gave us a happiness and innocence that we could never forget. Mira studied medicine; she was just one year ahead of me. Somehow, through the years, we drifted apart. I had left for England and later for Sweden and the connection was lost.

One year, Papa, Mama, Mirko, Noné Pina and I spent our summer vacation in Ston, a centuries-old Dalmatian town near Dubrovnik. It was full of time-worn, gray, weather-washed stone houses separated by narrow donkey pathways. There were many chapels and beaches. The name of the town came from the word meaning "stone." High mountains rose upward into the sky behind the town, and we used to walk the small paths that went high into those steep mountains.

Below was the shimmering dark blue Adriatic Sea. We could see the reflections of sunlight against the cliffs, which were gently caressed by large, slow-moving waves. We walked pathways covered with crushed shells and small stones that crunched under our feet. With the very hot summer bearing

down on us, the song of millions of cicadas hidden in olive trees serenaded us along our journey. We were engulfed in the complete harmony of a wild and wondrous nature. Mussel forests made with ropes, covered with growing treasures of nature, hung deep within the seawater. Mirko and I loved to swim near the mussel forest, often scraping our legs on the ropes. The shell-covered walkways led to one of the stone houses we rented for the summer, and during our time there, we were drawn by the smell of cooked mussels, reminding us of happiness and a complete peace both inside and out.

We felt a strong feeling of love for the nature surrounding us. Early in the morning, Mama would walk the donkey pathways to the open food market before the scorching sun rose. Later in the morning, we joyfully refreshed ourselves in the waters of the sea. That was our paradise on earth, full of happiness and peace. At night, we could see lanterns that were floating above the water on fishing boats, reflecting back the shadows of the deep, dark Adriatic.

> *Ribari*—The song of Dalmatian Fishermen
> by Vinko Coce
>
> > *Noć je mirna vali spavaju*
> > *Pod svitlom se ribe skupljaju*
> > *...Na pučini bile se sinjali,*
> > *Tiho kraju veslaju,*
> > *Malu barku guraju...*

(Translation from Serbo-Croatian 1990s)

The night is calm, waves sleep
Under the lights, fish gather
...On the seas, shining lights,
Towards the shore rowing quietly,
Urging the small boat on...

Vinko Coce - Ribari
https://gohvarblog.com/2012/07/05/ribari-the-dalmatian-fishermens-song/

# CHAPTER SIX

THE EDUCATION SYSTEM in Yugoslavia was similar to that of other European countries. During my time, it was quite competitive and rigorous and included four years of elementary school and eight years of middle and high school. My early school years were mostly uneventful: reading, writing in both Cyrillic and Latin alphabets, mathematics, history, biology, and geography took up most of my waking hours. I studied hard and finished my school years with all fives (As).

Starting in my fourth year, I went to piano classes after school, twice a week for eight years. I found magic with the music; it became an outlet for emotional expression. I was almost never able to practice on a real piano. My first lessons were on paper painted with the keys of a keyboard and laid out on the kitchen table. We didn't have enough money to buy a piano, but I had a great desire to express myself. Whenever I was able to, I practiced on a real piano at the music school, especially before a music recital when our parents were invited. When I was 16 and

playing Beethoven, I gave my first semi-solo concert in Belgrade. Best of all, I was allowed to play a piece I had composed myself.

Having a strict, Catholic upbringing from Noné Pina made me feel that I didn't fit in among the other students. I went to Catholic school and church most Sundays, but didn't understand why I should obediently kiss the hand of the cleric in long black and purple robes. All I wanted was to pray and to be left alone. My faith was strong enough to lead me forward. At that time in my life I needed a spiritual connection, but did not fully understand exactly what form it would take. I learned early one should endure disappointments, failure and temptations to succeed. I tried to find and acknowledge my sins and ask for forgiveness although I was not aware of committing any.

I always tried to live by rules. Today I feel it was an irrational but necessary step in my development. So I waited patiently to find the world of wisdom embracing it with a hope of a better life. Later, when living in other countries, Sweden and America, Mama and I would visit the church when it was empty. We both needed a purely spiritual time and connection in the depth of our faith. Illogical perhaps, but it gave us strength.

During middle school, we had *Folklor* after school, where we learned dances from the countryside and villages of old Serbia. We danced in circles to folk music, holding hands with the boys. Later, dancing was replaced by sports, as Mirko's generation never had *Folklor* dancing.

When I was fifteen, I had a friend named Veronika, and we shared a deep understanding of each other's need to express

ourselves. After school, we often walked the beautiful hills of Belgrade. Near my home was a hilltop, Zvezdara, and the closer we came to the top, the faster we would walk. The beauty of the forest intoxicated us. The hill was almost always windy, and the fresh air lifted our young spirits. We felt empowered and inspired by nature. Then we would sit on the grass with our notepads and write down our impressions. Veronika wrote poems and stories, some of which were later published. I wrote poems and short stories as well, never publishing them. I thought of them as my private hobby, written only for me. Many years after I left, I thought I had lost the ability to write poems. Gratefully, I was wrong. I now realize that my talent was hidden within my many years of work. I'm happy that this part of me was not lost.

About fifteen years later, when I lived in Sweden, I heard the sad news that Veronika had become a political advocate and spent years in jail for her strong opinions about the opposition. She was executed. For a long time I was sad that we hadn't kept in touch, but, at the same time I knew that we both tried to work toward a better future. I felt anger that we had to sacrifice so much in our lives and that we had to endure so many difficult situations just to survive emotionally and physically.

Our high school was divided into "standard gymnasium," with general language, science, and vocational subjects, and "classical gymnasium," which prepared students for entry into universities to study medicine, law and philosophy. For the standard gymnasium graduates, there were higher business courses, which prepared students for managerial professions. Medical education was an additional six years of university

coursework. Qualifying for university meant passing the lengthy examination called *Matura*, or final student exam.

My classic *Matura* examination included two hours of speaking, reading and writing in a foreign language, mostly English or French, as well as interrogation in other subjects for six hours by an examining board of 12 teachers. Failing this examination was disastrous because no additional chances were given. Failure meant you could forget any dreams of going to the university. Fortunately, I passed my *Matura* with a perfect score. I was not examined in English, which I spoke. Later, when I was given the opportunity to go to England for my internship, it was very welcomed knowledge. Sometimes it was hard to realize that all of my education and training would help me adjust to the many changes in my life.

It was in my teenage years when we began hearing new music on the radio stations from the West. Many girls wore wide skirts with layers of starched petticoats underneath. Everybody tried to learn the steps that we saw university students dancing, and we listened to the radio and embraced the new music with our bodies and souls full of happiness. I was one of those learning the fast dances and enjoying this new music... *Come on baby, let's do the twist*.... We couldn't fully appreciate the magnitude of the changing music world; what we did know was that we liked it, and we embraced it with all our youthful spirit. We called ourselves *the generation of rock and roll.*

It was the last year of high school, just before *Matura*, when many of my girlfriends whispered their longings to each other.

Some girls of my generation dreamed of personal freedom and a profession that would allow them full independence. Many dreamed of getting married and having families. For me, the liberation was to be able to make my own choices. My memories about life in Belgrade, where I lived for 17 years, are still very vivid. Daily activities revolved around school and family, which I thought was an ordinary life for the time. However, I was to later understand the extraordinary time and place and family I was blessed with. Somehow, at that period of my life, I felt that I was in a constant hurry to achieve new goals and move forward into the unknown.

# CHAPTER SEVEN

MY SUMMERS AS a young girl were spent mostly with family at home and sometimes on vacations; when I started gymnasium that changed. Students like me spent summers working for society as volunteers, which was part of a five-year plan for rebuilding the country after the war. One summer, we students lived on an island named Ada Ciganlija. Currently, this island has become a peninsula. The river basin just below Kalemegdan Park was filled in.

It is one of the Belgrade peoples largest and most beautiful recreation areas, with long beaches and picnic areas. And it was here, on the river Sava, where my father taught my brother and me to swim, along with so much more. I will never forget his words: "You can do anything you put your mind to, I know it." This turned out to be so true for us. This island was, and still is, an oasis of health, serenity, and culture.

In the late 50s, gymnasium students took pride in what we called "building our country."

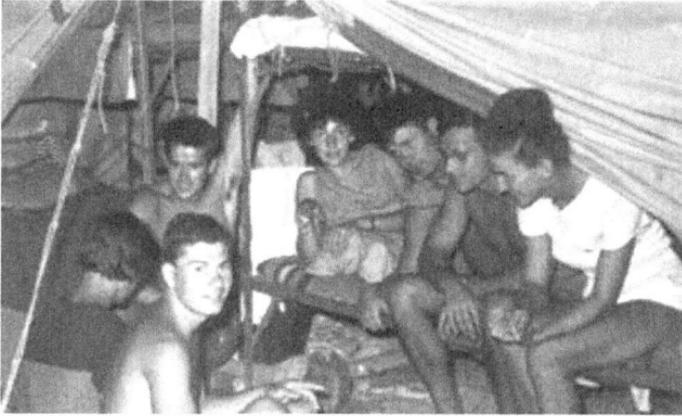

*Ada Ciganlija student volunteers 1958.*
*Photo used with permission from Dr. Borko Djordjevic/Mr.*
*Lopušina.*

Hundreds of us harvested corn on Ada Ciganlija in the heat of the summer. The corn was ripe, while the stalks were still green. We pulled the ears of corn and threw them onto a wagon that went along with us. Then we cut the stalks, tied them in bundles, and loaded them onto another wagon.

The majority of Ada Ciganlija was covered in wild vegetation, and it gave the island a spirit of adventure. At times, we would see deer and rabbits. Many seagulls, pheasants and quail lived there along with us.

We lived in tents covered with mosquito nets. We were so young and, of course, bursting with hormones, especially at night. A crisis was usually averted because we were so exhausted from the daily fieldwork; pleasure had to wait. The summer nights were very hot and humid, encouraging a world brimming with young desire. Despite the heat and exhaustion, couples would wander off in the evening to the surrounding meadows,

disappearing into the balmy summer nights filled with the sounds of cicadas, birds and flowing river waters. It was a mixture of young spirits, youthful enthusiasm, dreams and ambitions that would or wouldn't be fulfilled. My heart pounded many times without realizing what was missing. Somehow, I felt that my time for "the miracle of the unknown," the unknown physical expression of love and pleasure would come. So I started composing poems in my mind to capture my feelings.

Sometimes, while resting after hard work on Ada, I felt the winds coming from the Danube and Sava rivers, blowing my hair as I looked over the far horizon, expecting miracles to happen. I was fifteen years old and inspired by the beautiful forests and rivers of Belgrade. I remember a few lines of my poem about the wind, translated into English from the original Serbo-Croatian:

> ...Cold winds cutting through green fields,
> Yellow and red leaves flying in the air in whirlwinds,
> Eyes tearing up from happiness and desire,
> clouds escaping higher and higher
> fall engulfing nature and fire
> visible smoke here and there,
> fall arrived suddenly,
> fall arrived very early...

Tatjana Webster, Belgrade
1958

Another summer, we volunteered to build roads. To many of us, this was the greatest contribution we could make toward rebuilding our country. Our group boarded buses for our summer of work and arrived at the destination in about two hours. Soon we were assigned a sleeping space in tents near the road that would later connect Belgrade with Zagreb, Croatia. Today, it is a major highway, and today, for me and many others, it remains a symbol of our energy and hopes for a better life, which we channeled into road building.

Building roads was not romantic work. The girls slept in tents on simple cots, and every morning my tent mate and I would get up at dawn to be first at the toilets. We were up before the leaders blew their whistles signaling the start of the hard workday. Then we would run to the canteen where food was served. Breakfast was a worker's meal of bacon, eggs, cheese, fruit, bread, juice, milk and coffee. As work progressed, we would move further down the line to a new camp.

Our daily attire was gray overalls and boots. Students and the construction crew worked side-by-side hauling gravel and laying the hot asphalt. We took a mid-day break for lunch and rest, and then worked again until we were too exhausted to go on, usually around about five o'clock in the afternoon. We ran to be the first in line for the shower, and after dressing we ate supper. In the evenings, students would read or play chess. Some brought guitar-like instruments that we called *tambura* and formed a group to sing folk songs.

Later, I wrote poems and short stories about our summer of road building.

*Surrounded by vapors from the hot asphalt,*
*Heated from the scorching sun*
*We felt like dusty birds on the road*
*With shiny eyes, dirty hands, eager movements*
*The road was growing inch by inch*
*Together with our pride...*

Tatjana Webster, Belgrade
1959 (translated from Serbo-Croatian)

# CHAPTER EIGHT

B EFORE I DECIDED to enter the medical university, I wanted to follow the path of my friend Mira's older sister, Olga, who was an architect. I looked at the projects and plans she had brought home and felt inspired. Architectural planning was needed for restoring Yugoslavia's war-ruined buildings and streets. With a talent in precision drawing I had inherited from my Papa, I wanted to become an architect and applied to the Faculty of Architecture. However, several days before starting the architectural program, fate led me to the library, where I read a beautiful book entitled *The Life of an Egyptian Doctor*, by Samir Mahfouz Simaika. His life story changed my destiny forever. I transferred all of my application papers to the Medicine Faculty program.

The early 60s was a period when so many historical and social events were reshaping our society. The students at the University of Belgrade were full of ideas. Groups were formed in which discussion upon discussion kept everyone up late at night. Books and pamphlets were widely distributed among stu-

dents, and the fermentation of ideas was at full boil. I knew about those meetings, but never participated in them. I never felt that I belonged to the political society. My close friends and I were so idealistic; it was impossible to think that the opinions of others would change our way of living. My time and energy were entirely consumed by my medical education.

That time in my life demanded sacrifice, both material and spiritual, which shaped my later decisions. It helped me to build a strong desire to serve humanity and to right the injustices of the world. Long after leaving the university, I realized how naïve and blindly devoted to my ideals I had been at that time. I realized that these ideals were valuable, as they served me well and helped me along in my medical career. They helped me develop a critical approach in my professional life during my research years in Scandinavia and America. During my years of medical education, I began to experience the power of helping people, and that power elevated my soul and has remained with me for my whole life.

In the early 60s, there were not enough study areas at the library or the university. I remembered days, months and years of studying at home, sitting sometimes in the bathroom or on the steps leading to our small apartment on the fifth floor where the five of us lived.

There was a tiny area in front of our balcony that was big enough to place a small table covered with medical books, and that was my sanctuary. There, I found peace as I focused on my medical studies.

Many university students lived with their families while people from outside the city rented a room if their parents could afford it. My post-war generation was not used to luxuries like new clothes or shoes. I was so proud of my brother's green shirt that I wore most days of the week. Noné Pina made me one special skirt from a pair of Papa's old trousers, and I thought that life could not be any better. These simple objects gave me a constant warm feeling of belonging to my family, and a special connection to my brother.

# CHAPTER NINE

HE WAS MY first love: a tall, thin man with intense eyes and black curly hair. We met when I started medical university and one day he invited me for ice cream, and we started seeing each other. He was just one year ahead of me. With a twinkle in his eyes, he told me that I was his inspiration. He wrote a poem calling me "squirrel." His love was intense. It was a hot summer night in Belgrade, and the trees of Kalemegdan Park shielded us from view. The scent from the flowers and grass under a dark blue night sky full of stars was mixed with a young girl's expectations of becoming a woman. I thought this was romantic love. Today, I wonder if it was just peer pressure from girlfriends with experience or my own curiosity and a whirlwind of feelings. It was the early 60s, when "good girls" still waited for marriage before sex.

Even with all of the confusing thoughts swirling in my mind, I was not afraid, and I had enough courage to attempt this unknown experience in this romantic setting. When it was over, I had no desire to repeat it for quite a long time. It was

confusing, and I did not feel the experience was worth the effort. Personal differences in our relationship began to surface and the love did not survive. Exploring this new part of my life would have to wait for new growth.

I was left with mixed feelings of shame and failure, and a developing life that had to be ended. At that time, thousands of women underwent a "procedure." I was one of them, and I took memories with me that haunted me for a very long time. I remember lying on the cold examination bench in the hospital, totally scared and trembling with fear. One of the nurses came and snarled at me, "So you are one of the many women I have to deal with today," and left. Another nurse and a doctor came in, and preparations began. I was half-naked with my private parts exposed to unknown people who, thank God, totally ignored me. Then the procedure started and I began to scream. I really thought I would die.

The person "helping" slapped me several times. I wanted to disappear, to miraculously vanish from this place; I never lost consciousness.

"You acted as a whore," she said. "You will pay now."

And I paid with more screaming. No sedatives or pain medicine were given. The tissue was taken, they talked to each other, things were said such as "Maybe it could have been her son."

I was devastated and full of shame. I got up, put on my clothes without any help and left the room. *My punishment is done*, I told myself, *but I am not free.*

Mama was waiting for me outside. We walked through the streets of Belgrade toward our home. Taxis were expensive, and I thought I needed to clear my head. Mama had tears in her eyes while she was holding my hand. She knew how I felt. It was my decision and only mine. Mama and I had an agreement that neither Papa nor Noné Pina would ever know our secret, and I came home and pretended that nothing happened.

Noné Pina asked, "Why are you so pale?"

"It's cold," I said, "that's why," although it was early summer.

That night, before going to bed, Mama hugged me, comforting me with her deep love and understanding. She said, "Everything will be fine, you will see."

I knew somehow that the horrifying event I had experienced would leave me deeply scarred. A long time later, when I lived in America, I learned that my first love became a neurosurgeon in the Republic of Bosnia. He never knew my secret but he named one of his daughters after me.

*...Lost in the grass,*
*Lost among flowers,*
*lost with powers,*
*with winds in my soul,*
*innocence did fly,*
*among dark clouds in the sky,*
*leaving shadows in my heart*
*without sunshine...*

Tatjana Webster, Belgrade
1961 (translated from Serbo-Croatian)

# CHAPTER TEN

I LOVED EVERY minute of medical education, but medicine never prepared me for the tragic death of my grandmother. The memories I have of her are still so vivid.

Noné Pina was one of the rare women of her time who finished the Catholic college for women in Dubrovnik. She was named Josefina after her father, Joseph. We called her "Pina." She had the Italian name "Noné," for grandmother. She was widowed at the age of 36. Her husband was Miro, my brother's namesake, and my grandfather. Miro Lukić had been a teacher and later became a banker. As a young man he had been an Olympian on an eight-man rowing team. He died of tuberculosis several years before World War II. Noné never complained; she declared that she would never have another male friend or re-marry. So she lived the rest of her many years with her daughter, my Mama.

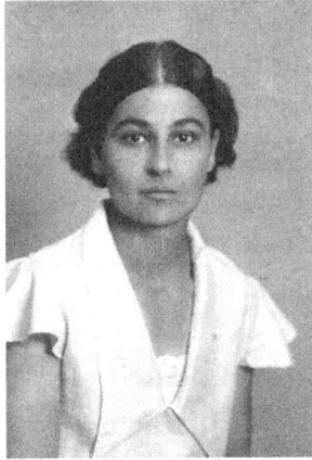

*My very proud grandmother, Noné Pina: Split 1933.*

Josefina Lukić was an impressive woman of average build, with black hair always in place, and dark, piercing eyes. She presented a stern face, red lipstick, upright posture, and she was always well dressed. Noné Pina was never sick, except for her glaucoma. She had enormous amounts of energy. I was a little frightened of her; my brother, Mirko, who I remembered was her favorite, was not.

As a child, I was aware of my curiosity and slight fear of Noné. At thirteen, I discovered that I had greenish eyes and slightly curly light brown hair. Noné would appear in the bathroom where I was looking at myself in the mirror, and she would say, "What are you looking at?" Then I would turn away from the mirror in shame.

She would say, "It is nothing to see, go and do your homework."

I would reply, "Nothing," and then leave.

Noné taught Mirko and me cooking, washing, sewing, cleaning and making beds, pointing out that my brother always did it better. If I did not perform the tasks to perfection, I was obliged to repeat them to her satisfaction. We both grew up under Noné's authority, where the paths for the present and future were clearly understood and accepted. At the same time, our parents worked and provided financial means. Sometimes tension hung heavy in the air at home, where the five of us lived together in such a small space. During these times, I prayed that I would become invisible and somehow be given the power to resolve the tension. Feelings of fear and conflict stayed inside of me for a long time. I was shaped to diligently avoid conflicts, always hoping for a peaceful solution. Later in life, I came to understand Noné's way of showing love toward us; however, it was difficult at times, although, it proved to be immensely valuable. In the evenings when my parents returned from work, we were showered with their love.

Noné Pina spoke a mixture of Italian and Croatian. So early on, I also could speak some Italian and Serbo-Croatian that my parents used. Sometimes, I would forget and say the word "kruh" the Croatian word instead of "hleb" the Serbian word for bread. That was not always accepted in Belgrade making us different in others' eyes by the way we spoke.

Noné Pina contributed to the family's finances with her pension, as well as passing her housekeeping experience down to us and caring for us during the day while Papa and Mama were at work. As we came to realize later, these housekeeping skills were useful to Mirko and me in our daily lives when we grew older and

moved to Sweden and America. It was easier for both of us to handle life's complex situations because of our family closeness and the strict discipline that Noné had provided us.

One day, I was sitting at the table studying forensic medicine, so ironic, as you will see. Noné casually said, "I am going out for a little while to buy food." And that was the last time I spoke to her. She stepped outside to cross the street, and a bus hit her. The impact left her with a massive cerebral hemorrhage, and two weeks later, she passed away. The white corridors of the hospital with the strong odor of formalin are still vivid in my mind. As an almost doctor, I couldn't accept the reality that she was dying in the hospital corridor and I could do nothing at all about it. We were told that there were no available beds, as many younger accident victims were being admitted and given beds because they had a higher possibility of survival. I will never forget the feeling of betrayal and total powerlessness that I felt at the time.

Mama showed enormous strength at Pina's memorial in Staro Groblje, the old cemetery. We buried my Noné among the sculptured monuments and mausoleums, beneath the cypress, oak, pine, poplar and chestnut trees, close to the top of a hill that sloped down toward a valley. On the other side of the valley was the city of Belgrade. I know that her soul belonged in and probably flew toward her Croatian home of Dubrovnik. Noné Pina was 69 years old when the accident occurred. She was a very proud woman who we loved and respected. Only the passing of time would show me how much love and support she gave us during our life together.

# CHAPTER ELEVEN

THE LAST DAY of medical school was a grueling eight hours of testing. I finished with the highest scores in the class. I came home afterward and told my family that I had finished. I finally had my medical degree, which opened a whole new world of possibilities. Everyone was proud, knowing that it was the beginning of things that many only dreamed of. But, to become a practicing medical doctor, I had to complete another year of training. Being top of the class, I was offered an internship either in Germany (not popular because of the War), Finland, England, or Belgrade. I chose England.

I left by train from Belgrade, excited and full of anticipation as my family and I said goodbye. The train passed through Hungary and Germany, with stops in Budapest and Munich. The next morning I arrived in Paris. I hoped to see the river Seine as we passed through the city, but it was not on the route.

My heart was pounding with excitement. I was in the city that people all over the world dreamed about, the "City of Light and Love." I walked to the information board to see what time

and gate the train to Pas de Calais would depart, thinking that it would be just a few hours. However, I quickly realized that the train to Pas de Calais was the next morning.

With a suitcase in my hand, I found a taxi. The taxi driver asked me where I wanted to go, and I answered automatically in French, "La Tour Eiffel, s'il vous plaît." The Eiffel Tower, please. I did not know why I chose that location.

"Très bien," he replied.

It turned out that my spontaneous decision was not bad at all. From the taxi window, I saw L'Arc de Triomphe, a few Renaissance churches, gardens that lined the Champs-Elysees, and finally, I arrived near the Eiffel Tower. I was awestruck by the view. I asked the taxi driver about cheap accommodations nearby, and he gave me the address of a small student hostel. After putting my suitcase in the room, I left, eager to explore my surroundings.

Reading the information plaques (fortunately, I spoke French), I learned that the Eiffel Tower was built in 1887 and that it was constructed of wrought iron. It was erected as a symbol of hope and power and offered the most beautiful panoramic view of Paris. It had 1,710 steps, and visitors could climb the stairs to the first level. If you bought a ticket, elevators would take you to the top floor—I didn't have enough money. So, from the first level, I marveled at the view of the Notre Dame Cathedral, the Tuileries Gardens, the Louvre Museum and the Arc de Triomphe.

The next morning, I was back on the train, traveling through France to Pas de Calais. This was my first trip outside

of Yugoslavia. The University had bought the cheapest ticket for me, and my "accommodations" for the English Channel crossing would be on the top of an enormous boat.

*I am wearing my white vinyl coat before leaving for England:1965, Belgrade.*

This was the year I turned twenty-three, and I wore a white vinyl knee-length coat that my family had given me for the trip. I was very proud; it was the most beautiful thing I possessed at the time. I thought I looked "mod" and sophisticated and that I didn't need a scarf or gloves—was I ever so wrong. Although it was a warm summer month in Europe, it would prove unusually cold, windy and damp on the Channel between France and England. I considered a scarf and gloves to be objects of indulgence. That was a period during which I thought a minimalist life was a high achievement. My leaving life in

Belgrade with the clothes I was wearing and not much else, without regrets and moving forward to a new stage of my life, was an attempt to prove I was the type of woman capable of throwing myself headlong into an exciting adventure in another country, a leap into the unknown.

"Dover," I said, boarding the enormous boat in France at Pas de Calais. A man extended his hand and took my ticket, then pointed toward the top of the boat, which was at least four or five levels up. Enormous excitement came over me, as I was anticipating that I was approaching "something big." My ticket assigned me to the top level, which seemed like something to be proud of. After all, I would have a nice view from the top of the boat. At first, I thought the top was the first-class accommodation, but, as it turned out, there was no cabin, and it exposed us to the elements. I realized then that it was not first class at all.

My cheap university ticket sent me on a very cold, windy trip to England. For many hours, I thought I would freeze to death. Initially, I told myself, "I am not cold," but my shivering betrayed me and became more intense as we approached Dover. My self-importance was shattered. Once again I told myself, "It is nothing, I will endure." A few raindrops began to hit my face, my destination was on the horizon, and excitement again lifted my spirits.

A startling play of silver-blue light and shadows set against the few low buildings suddenly appeared on our approach to Dover. As we docked, the trees became dark shadows against the

sky. There was nobody waiting for me, so I picked up my suitcase and headed toward the nearby train station.

From Dover, I boarded the train to Newcastle-upon-Tyne. I did not expect that my final trip would last several hours. Hunger gnawed at my middle as I was pushed on by the anticipation of finally reaching my destination. To me, the train was luxurious, with red plush seats and ladies dressed in nice clothes, some even wearing gloves, and gentlemen in travel suits and the obligatory very British umbrellas. I remember that I was so surprised at how clean the train was. A very nice lady sitting across from me offered me an apple. Life was good again.

The beauty of the English countryside amazed me as green fields and flocks of sheep passed by outside the windows. Occasionally we would see large birds flying as we crossed several rivers in the fast-moving landscape. My anticipation was building, and after a few hours on the train, I arrived at my final destination, the town of Hartlepool, a little south of New Castle-upon-Tyne. When the train pulled into the station, I saw the town sign, and as I stepped off with my luggage, a new energy flowed into me. It had been a long journey from Belgrade, crossing most of Europe, one that involved switching from train to boat and then from boat to train again. The trip lasted over two days and left me full of excitement and adventure. Sleep was what I was not able to find, but I didn't feel it. I took a taxi to Hartlepool's Cameron Hospital, my first assignment for rotations in the New Castle area. I paid the driver and then stood beside the road with my single suitcase. I had finally arrived. I paused in front of a large, red brick building on the

shore of the North Sea, where the taxi driver had pointed out the hospital sign as he drove up to the front entrance. I carried my suitcase up the steps to the door; it wasn't heavy as I didn't have much in it, and with my very last ounce of energy, fueled by my excitement, I pressed the doorbell. When it swung open, a nurse met me. Her face told me that she wasn't one to tolerate nonsense.

"Yes?" she said.

"I'm here for the medical internship," I said, speaking the English words carefully. "I came from Yugoslavia."

A small look of amusement came over her face, like the first light of dawn.

"Ah, yes," she said, looking at her list and then trying to pronounce my last name. She was close to pronouncing it correctly.

I nodded and without further introduction, she walked down the hall with me behind her as I took in my surroundings. A leap into the unknown began as we walked down these halls of my life in a new country. The nurse, I later learned, was named Sister Janet, and she took us to and up a well-worn set of marble stairs to the next floor.

On the second floor, we went down a long hallway. "This is the bathroom," she said, looking to the left. I saw a simple bathroom with a single bathtub, a rubber hose connected to the tub faucet. "There are six of you on this floor. You share it." Sister Janet nudged another door open with her hip, "This will be where you sleep."

I stepped inside, taking everything in. The room was simple, with a wooden floor and a small carpet beside the bed. My room was about six by eight feet, with no window, bright blue wallpaper, and a narrow single bed in the corner draped with a thin green bedspread, a pillow at the head, and a red hot water bottle at the foot. A tiny laminated desk with a lamp stood in the other corner, seemingly waiting for me to start my new lessons.

Sister Janet showed me where to set my suitcase down. "We serve breakfast every morning at six-thirty and supper every evening at six- thirty as well," she said. "If you have questions, come see me."

"Thank you, Sister," I replied.

She gave me a little smile and then left the room. As soon as the door closed behind her, I fell face-first onto the bed with my clothes and shoes still on. I slept like that for a full day. When I finally awoke, an untouched tray of food lay next to my bed. The sight of food awoke my hunger, and I ate the whole plate of cold food very quickly, as I usually did. The nourishment soon restored my energy. Then I washed up, changed my clothes, and left the red brick building that had looked so very impressive on my arrival. I was ready to explore. Fortunately, I had arrived on a weekend.

The coastline was the most beautiful area, with desolate beaches, wind-worn castles and their ruins. These were magical islands with huge North Sea waves breaking against the shore with deep rolling, roaring sounds. High and low tides with the dramatic ebbs and flows of the sea flooded several terraces. The

terraced sea walls were covered with seashells, crabs, seaweed and a very strong sea fragrance, leaving me in wonder.

Later, I discovered one of England's most beautiful landmarks nearby, the enormous Durham Cathedral. As I climbed the tower's 325 steps, it left me breathless, more from the beauty than the exercise. There were many twelfth-century wall paintings inside the cathedral, all brimming with the glory of past eras. It remains one of my favorite memories. To me, all of northern England was filled with exciting mystery, the fog-covered moors, the heavy accents and the slow rhythm of the past.

*I am standing on the shore of the North Sea,*
*by cliffs in the wet grass,*
*feeling energy flooding toward me,*
*looking at clouds that pass,*
*reaching the land and the sea.*

*Light and shadows are in play,*
*painting art in array.*
*The song of the waves roar,*
*birds screeching*
*food searching,*
*wings elevated by the wind gliding.*

*I let my soul fly into the sky.*
*Will I be able to open my eyes,*
*I let my hopes fly.*

*Will I find golden rays,*
*filling the red morning sky,*
*and yes, I know I will try.*

Tatjana Webster, England
1966

# CHAPTER TWELVE

THE EXPLORATION OF Hartlepool ended my first weekend in England. Sunday night was full of tossing and turning. Tension was building inside me. In the early morning hours I woke in my dormitory room and soon headed downstairs to the first floor dining room for breakfast. I looked through the windows and could see only gray, thick fog. My life in medicine began that morning, as the fog coming in from the North Sea hid the entire hospital from view. I felt like I was embarking on a very important personal trip.

Others had arrived for breakfast and were sitting around the table. I pulled out a chair and sat down. Nobody said anything at first, so I wished everyone a good morning and admired the bouquet of flowers in the middle of the table. To my left and right were many foreign interns, some from Pakistan and Iran, some from India and still others from Poland and France. I guess we were a small United Nations.

Soon, Sister Janet and another nurse came out of the kitchen bringing with them a full English breakfast of eggs, toast,

bacon, fish and chips, coffee, baked beans, and black pudding and set the dishes in the center of our table. I had never before seen these last two items being eaten at breakfast. After the food was on the table, we passed the dishes around. It was chaos, as different cultures have different customs about passing food. I accepted the egg dish from a young man seated next to me. He looked to be from India. "It's my first day," I said, taking the serving spoon and helping myself. He stuck out his hand and, in a very formal manner, said, "Then allow me to welcome you to the first day of your career." I took his hand and welcomed his warm acceptance.

We began eating breakfast, with each group involved in small talk in different languages. Some of the food was familiar to me, and some was not, it was all nourishing and good.

"What do you think of the food?" the young man said in English.

"It's very different," I answered.

"Yes," he replied, and we began eating.

I've always thought the flower arrangements were the best part of our dining. The taste of English food was different. Sugar was added to most recipes, even to meat. Sometimes, in the afternoons, if our schedule allowed, we would have puddings, cakes, and tea, which was closer to my way of enjoying sweets. I wasn't used to the liberal use of sugar in nearly every dish. I preferred my sweetness to be delivered in traditional ways.

Many times during meals, my thoughts would wander back to Yugoslavia where, on special occasions, Mama went to a bakery and bought a pie called *burek* made with phyllo dough

stuffed with ground meat, cheese, or spinach. She would bring one home and we felt like it was a cause for celebration. Coming from my war-torn country where rationing was still in effect, I thought that here it was a miracle that we were able to choose what we wanted to eat. To those of us from a different part of the world, our liberation was in full bloom.

For the main course in the evening, we could select from very spicy Indian food, distinctive cheeses, rice dishes, or different meat pies and bean dishes that I didn't like. Despite this bounty, I missed the food my Mama had cooked, typically Mediterranean, with lots of fish, vegetables, and fruits, as well as Serbian dishes, with grilled mixed meats, potatoes and a variety of salads. However, during my internship the menu was not of great importance; my professional goals took priority.

For most of my fellow interns, this was the first stop on their way to America. They planned to leave England after training because of higher pay in the United States. Personally, I was just looking for a good position anywhere after the year was done.

We finished breakfast and hurried to our assigned areas. A goal-directed expediency was constantly pushing me to the next levels of training. That day, I was given green surgical scrubs and white shoes, which remained my primary attire for the year I spent in England. I rotated to different medical services between the hospitals in Hartlepool, Newcastle and London. I saw my assigned patients every day on rounds, and I felt like I was a bird allowed to fly free, especially in the orthopedic surgical suite. Enormous satisfaction came when performing small joint surgeries under the attending surgeon's supervision. I had loved

anatomy in medical school, and that knowledge was extremely helpful in surgery.

One day, as I was leaving an operating room, I met a reporter from the *Daily Mirror* who asked for an interview. After getting permission from the school, I spoke to him about my experience in England. He wrote an article about the "young woman doctor from Yugoslavia." I thought the photo of me in my surgical scrubs and cap was unflattering, but at the same time, it made me very proud because the article finished with the words: "We hope she will stay and work in England."

My first experience with earning an income came from the government stipend I received while I was in Great Britain. It had a huge impact on my feelings of self-worth. Now I realize it was tiny. However, at the time, I felt a great achievement, which compensated for my feelings of poverty. So one day, while out walking along the nearly empty streets of New Castle, I bought a blue summer dress and a roll of very nice light blue wallpaper for my family's apartment in Belgrade. It felt good to contribute an improvement to life back home, because at that time, wallpaper was a novelty for those living in our neighborhood. However, I later found when I returned, that the single wallpaper roll covered only one wall of the foyer, but it was on display for anyone looking in.

From Newcastle-upon-Tyne, I was assigned to the St. Thomas Hospital in London on the river Thames, just across from the House of Parliament. Everyone comes to London with high expectations. However, nothing could prepare one for life in this old, fascinating city. Most of the streets were narrow and

filled with national history, art, architecture from many cultures, and a rich mixture of all languages could be heard in passing.

I started there in Internal Medicine. During those months, I was introduced to rheumatology research, and I fell in love with a new world of science. There was one big "however:" to continue in pure research, I would have to obtain either grant support or private funds. I had no experience with grants; I was told that it would be impossible to work for private pay without a work visa. My burning desire to explore my newfound path in medical science would not leave me, and I was certain that I would find a way to succeed sooner or later.

When not engrossed in my work, I would often go to Westminster Abbey, one of London's treasures. The building was a magnificent mixture of architectural style considered to be the finest example of English Gothic in existence. I loved to visit a hidden area called Poets' Corner, where you could find the final resting places of Dickens, Tennyson, Kipling, Shakespeare, Bronte and others. I felt inspired, and parts of the poetry I wrote at that time come back, even now.

> *...fog creeping slowly from the North Sea*
> *Engulfed the nature and people,*
> *Silence was palpable, where did birds fly?*
> *Roaring sounds from the sea waves are gone,*

*Sounds from church bells disappeared*
*We barely can see each other,*
*Thick fog is everywhere...*

Tatjana Webster, England
1966 (translated from Serbo-Croatian)

While I was finishing my internship in London, a letter from Papa arrived. He had found a Belgrade newspaper advertisement from the Swedish Medical Association recruiting foreign doctors. Before my arrival in England, I had applied for a position at the University of Belgrade and had not received an answer. Papa suggested that I consider the Swedish position when I returned home.

By the time I had completed my internship in England and returned to Belgrade, I was eager to explore this new opportunity in Sweden. I felt that time moves on with ever-increasing speed and plays havoc with the things we once had thought would be left for tomorrow. Time steals our opportunities if we aren't careful, seizing them as quickly as they appear.

# CHAPTER THIRTEEN

I WAS ONE of eight-hundred-and-sixty doctors from Yugoslavia responding to the Belgrade newspaper advertisement for jobs in Sweden. The Medical Association of Sweden sent a group to Belgrade to interview us all, and I was one of the successful candidates.

Fifty-six young doctors chosen from all over Yugoslavia were sequestered for three months in a hotel in Tasmajdan, one of Belgrade's beautiful parks. We were to learn Swedish by the direct method, meaning no books, speaking only Swedish during all of our activities, listening and learning the correct pronunciations. We were assimilating into a new culture and language in an environment steeped in our past history. Maybe the knowledge of our past gave us a clear direction into the future.

The Tasmajdan plateau was for many years a stone quarry. During their 500 years of occupation, the Turks named it *Tas,* meaning stone, and *Majdan,* meaning mine. During World War II, people hid in the caves from the bombing. Above the caves is a large park, almost in the center of the city, green in summer

and white with snow in winter. Such a paradox; we were living in the heart of our homeland, preparing to leave and look for paths of survival in an unknown, new country.

Preparation of legal documents and learning a new language occupied our minds, so little time was left before that emotional final day. All of us were standing at the bus station in Belgrade waiting to go to the airport. Only two days earlier, I had received a letter offering me a position at University of Belgrade Department of Anatomy. I felt validated by the offer. However, my excitement about the possibilities waiting for me in the unknown was more powerful. I felt that the world had more to offer, and I was full of a sense of adventure, pulled by the unknown toward something that I could only imagine.

The human spirit may be a fusion of mind and body, a mysterious force that escapes with a river of emotions. I was hit by feelings of enormous guilt and sadness about leaving my family. I remember the tears in Mama's brown eyes and Papa's green gray eyes as we said goodbye. Mirko hugged me saying, "I will see you soon." There was pain in my leaving, as well as hope that I would succeed. At that moment, I decided that I would have a mission in life to keep us together emotionally, no matter how many miles apart we were.

# CHAPTER FOURTEEN

FEELING THE LOSS of togetherness and family weighed heavily upon all of us new doctors as we boarded the Yugoslavian Air flight to Stockholm. We were embarking upon a new life in a new country. The thoughts of being chosen for this new chapter in our medical careers were clouded by the memories of families we were leaving behind. We were soon in the air, flying toward an unknown place. We landed for a short time in Poland for fuel. Military tanks and troops were at the Warsaw Airport. Knowing that there had recently been tension between Poland and Russia, panic came over all of us. Fear was in the air as we refueled and continued on our way without incident. We were reminded of how fortunate we were because Yugoslavia allowed freedom of travel.

After several hours of flying, we arrived at Stockholm's Arlanda Airport. Then, descending from the aircraft, large snowflakes were falling covering the tarmac and the ground crew. In the distance, we saw only white trees. Our first impression of Sweden was the overwhelming silence. Nothing

could have prepared us for the quiet peacefulness in the surrounding nature and people. We felt like we had arrived on a different planet. This was only the beginning. A little while later, in the middle of the day, a gray-blue light from the winter's northern sky shone through the clouds. Our trek into the unknown continued.

It was November in the late 1960s, and I was with our group of Yugoslav medical doctors in a bus approaching Uppsala, our city of learning. Looking out through windows partially covered with ice, we saw Gothic architecture everywhere, the Cathedral, the Castle and Uppsala University. As we approached, we saw the spires reaching upward, beckoning to all seeking knowledge to gather near. Our team leader, speaking in Swedish, of course, provided a narrative as we went along. Uppsala is the oldest university in Sweden, and it was built along the banks of the Fyrisån River. It has a long and glorious history extending far beyond the borders of Sweden. My excitement was building, and I had the sense that a bright future was within my grasp. I would embrace my new country, as unknowns were becoming knowns. I said a prayer of thanks and thought about Papa's vision of a better life for me.

In addition to reviews and testing in medical science, we were introduced to the Swedish political and socioeconomic systems. Daily training classes in the Swedish language and the social seminars kept me fully occupied. To further assimilate and learn the language, we were placed in homes scattered throughout the city. For the next three months, I was assigned to live with a woman in Uppsala who worked in daytime television.

Since there was little time for us to speak Swedish, I spent my day listening to Swedish news and Swedish and Norwegian music on the radio. Many of the Yugoslavian doctors felt lonely because they seldom communicated in their native tongue. Although we occasionally spoke our first language, our teachers did not recommend it.

We lived in this idyllic university city for about three months. I felt the excitement of being there, but my Yugoslavian colleagues were more reserved as they tried to adjust to this welcoming, open, Swedish society. I could feel their internal conflict. In Yugoslavia, you took great risk speaking openly about political or social ideas. However, emotions and opinions there were more freely shared.

I was eager to explore Uppsala, which had begun as a small university town in the fourteenth century. There were historic plaques placed throughout the university campus, which taught us about Swedish scientists such as Carl Linné and Andreas Celsius, both of whom gained worldwide prestige for Uppsala University. Our group was learning Swedish history and social life every day. I enjoyed the atmosphere of the old parts of the city and its historic importance. My newfound knowledge about social and historical Sweden sparked a desire for more. I felt free in my new environment.

I saw different places every week, and I was learning more every day. We were invited to our teachers' homes for dinner and conversation. We found out that it was customary to leave our shoes and boots in the foyer and then join people in the living room. Their furniture was Scandinavian design, of course.

The seats were low and made of light birch wood with fabric cushions. The homes featured clean lines with just a few carefully placed decorative details.

As we entered from the outside darkness of winter, greeting us was a cheerful atmosphere, lit by candles and shaded lamps. Christmas was approaching and I thought it was wonderful to openly celebrate and was starting to feel freedom. Assimilating into this culture would be easy for me, and I welcomed it with eager anticipation, thinking, "this is good." Prior to dinner, we were served the Swedish traditional holiday drink called *glögg*. It was warm, sweet and spicy, with raisins and slivered almonds in wine and brandy. The strong cinnamon scent wafted through the whole house, intensifying the holiday feeling. I thought again that it would be easy to make my home here.

Discussions with our hosts were long and interesting as I freely compared our daily life in Sweden with the one left behind. I was learning about my new country. I loved the daily Swedish life that, for me, was full of new routines. There was an acceptance in the Swedish culture that suited me perfectly. I loved every moment because it was calm, elegant and full of understanding the needs of others. The Swedish culture became a part of who I am. It defines me, and I will carry it with me for the rest of my life.

A few weeks after we arrived in Sweden, the Swedish Medical Society formally presented us at Stadshuset, the City Hall, which was an impressive red brick building where every year, on the 10th of December, the Nobel Prize is awarded. At night the tower is dramatically lit from the base with upward

pointing floodlights. On the top are the Carillon and gilded weather locks (vanes) with the three crowns from the national coat of arms, the symbol of Sweden.

For the first time in my life, I was able to buy a beautiful long dress, the color of the Adriatic Sea, which I wore to the formal dinner at Stadshuset, given in our honor by the Swedish government. There were many other guests seated at very long, beautifully decorated tables in the Bloa Hallen, the same Blue Hall that had hosted the Nobel Prize ceremony two weeks earlier. As we sat there, speeches were given to welcome us to Sweden and to recognize our group, and then dinner was served. As we left the Blue Hall, we passed through Gyllene Salen, the Golden Hall. The walls were decorated with bright mosaics that were made from about twenty million pieces of gold. Our group was struck by the majesty of the evening, and we all felt very proud to be a part of the Swedish celebration. We were in awe of being in this renowned place. All of us from our group of Yugoslavian doctors deeply felt the magnitude of that moment.

A few days after Christmas, they informed us that we had all passed our medical, cultural and practical language tests, and our careers as medical doctors in our new country could finally begin. We left Uppsala and traveled to our assignments. Mine was in Stockholm, and once again I was leaping into a new unknown.

Based upon our test results, we were all placed in different hospitals throughout the country. I received a letter assigning me to the prestigious Karolinska Hospital, and a small spark of pride flashed inside me. I started training in the ophthalmology

department, and a new door opened for me with the beginning of my practical education. We were supervised and taught many different medical and surgical procedures. After several months of training, I was allowed to perform a cataract surgery with oversight from one of the doctors. I was told that my hands were strong and delicate, and that I demonstrated a very calm disposition, which was expected from me as a doctor. This was a wonderful and grand beginning for my life in Sweden.

# CHAPTER FIFTEEN

IN THE LATE 60s, my brother, Mirko, came to live with me in Sweden. Soon after finishing gymnasium in Belgrade, he also began the journey to assimilation into Swedish life. For the first few years, we shared a two-bedroom apartment in Stockholm on the first floor of a three-floor building perched on an island hill, one of fourteen islands connected by ferries, bridges, trains and subways, both above and below the sea.

I remember it was in March when my brother was born, and I was five years old. I stood in a small garden outside the hospital with Noné Pina and Papa. They said, "You have a brother now." I went close to the fence and picked a few flowers to make a small bouquet for him. I was overwhelmed with happiness, a feeling of belonging to another and of togetherness that has stayed with me all my life. Then Noné Pina and Papa took me to where my Mama held in her arms a beautiful, doll-like baby, so small that I thought I could play with it. It was an unforgettable moment when I saw his beautiful face with eyes

that I thought were looking up at me in surprise. I gave him a kiss on the cheek and tried to give him my flowers.

We both grew up surrounded by feelings of love and understanding. I remember that I felt like I had a mission to protect my brother. I held him under his arms when he learned to walk, bringing me feelings of happiness as his big sister. Mirko was a younger, post-war child, and life was much better for him. Our parents worked every day, with Noné taking care of us, our family providing Mirko with security and safety and love.

On first arriving in Stockholm, Mirko began intense studies of the Swedish language. After finishing language classes, he enrolled at the University of Stockholm, working toward an engineering degree. After I moved to Linköping, about a 2 hour drive south of Stockholm, for my fellowship and specialization, he transferred to Linköping University, and so we were again in the same city. After several more years of study at the Institute of Technology (Tekniska Högskolan) at Linköping University and the nearby city of Norköping, he earned his degree and was hired as a mechanical service engineer at Saab's main military flight division as a calibration specialist where he worked until he retired. (His department was later part of diversification and became an independent contracting agency).

He was named Mirko after our grandfather. My brother is of medium height, with a muscular build, light brown hair and dark brown eyes. His personality is very outgoing, and he is quick to meet new people. He is musical, surrounding himself daily with music just like I do. Growing up he played the violin, and sometimes we would perform together, he on the violin,

and me on the piano. However, music soon took a backseat in his life to sports, especially tennis. Tennis has been Mirko's life-long hobby, and he remains very active in his tennis club. Recently, his Swedish tennis club was invited to play a series of matches with a tennis club in Serbia. He didn't play because of a shoulder injury, but he spoke the Serbian language so he gave commentary on local TV as the Swedish team played against the Serbian home team.

Four years after moving to Linköping, I began my specialization in nephrology (kidney disease). Soon after, my parents emigrated from Belgrade. Mama came first, and then Papa moved to Linköping later, waiting until he was sixty-five to retire from the bank. We all loved our quality of life, and on weekends when Mirko, Mama and I needed more adventure, we would visit Stockholm.

We often drove along Stockholm's Strandvägen, a large boulevard with boats docked on one side and stores and apartment buildings on the other. We usually parked near Stadshuset, City Hall, and then we would walk through the city streets for hours, filled with the spirit of a new adventure. Mama would bring sandwiches from home for us to enjoy. We passed by beautiful hotels on Stockholm's fashionable boulevards where celebrities and royalty resided when visiting. Mostly we enjoyed looking at the architectural style of the old buildings and watching the large ships and sailboats passing by.

During our exploration of the city, Mama and I loved visiting the National Museum on Blasieholmen Island, on the opposite side of the Royal Palace. I have always enjoyed mus-

eums and paintings. They had an extensive collection of old masters and impressionists, such as Rembrandt and Monet. After our visit to the museum, Mama, Mirko and I sat on a bench near the water, in the shade of the large trees, watching seas gently rocking the boats while we ate our sandwiches.

Some weekends we visited Djurgården Island, where we went to Gröna Lund, an amusement park with roller coasters, ferris wheels and fun houses. I remember that Mama and Mirko enjoyed the roller coasters, not me. We would visit the nearby Skansen, an open-air museum that opened in 1891 to show how people in Sweden lived before industrialization. Mama liked watching glass blowers in their traditional workshops. One day, we bought two small vases that we had made, blowing and forming the molten glass ourselves. They still decorate my living room in Florida.

Mama, Mirko and I enjoyed walking through Djurgården Park in the fall, over the ground carpeted with red and yellow leaves. Some weekends we would walk through the streets of the Old Town, Gamla Stan, on one of the largest islands, Stadsholmen. I always had my camera ready to take pictures. The island of Gamla Stan is rich in Stockholm's historical heritage; when you visit, you begin to feel like you're a part of that history. We loved mingling with people in the bustling streets, and I loved to explore the bookstores and antique shops. They transformed many medieval cellars into restaurants and coffee shops, and the narrow cobblestone streets were reminiscent of medieval times. We would buy espresso and soft ice cream and

then sit near the windows to watch people walking by. I'll never forget those days of enjoyment and happiness.

Gamla Stan with its narrow cobblestone streets was a wonderfully restored and preserved part of the city, and apartments there were among the most prestigious addresses in Stockholm. After hours of wandering about, we would sit outside a small restaurant on the square, facing *Storkyrkan* (Big Church) and the statue of St. George slaying the dragon. We enjoyed the smells from the bakery while basking in the light breezes off the water of the Baltic Sea.

In Nordic countries, people long for spring after enduring the dark days of winter. When I lived in Sweden, the winters seemed endless, with frigid Arctic temperatures and an almost complete lack of sunlight for months. After the dark winter, I would see Swedish people standing on street corners, at crossings, at traffic lights and any other spot they could find in the sun, just soaking up the warmth of spring. Others worked outside of their houses and on the water in their boats, preparing for the summer. Summertime was very special, with the vibrant colors of blooming flowers scattered in the fields of bright green grass, along with the green of the forest and trees in the surrounding nature. Today, with global warming, the climate in Sweden is not as harsh, but the sunshine of the spring and summer is still very welcome. I often relive my memories of Sweden and wish I had had more time then to explore the many treasures of that incredible country.

Mirko fell in love with a lovely Swedish girl named Ann, and they married and started their family. Thus, we began on

our new, parallel lives. I was working on call one night at the university hospital when a nurse told me that my niece, Sandra, had been born. I went onto the delivery floor and saw a small beautiful baby in a white blanket, with barely opened eyes, rosy cheeks and a tiny, flower-like mouth. It was an incredible moment that I will never forget. This was our family continuing to grow.

Later, I would move to America, where I kept in close contact by letters and telephone with Mirko and my family in Sweden. When my younger niece, Linda, was born, I was living in America and I didn't see her for almost three years because of problems with obtaining a permanent visa (green card). I wanted my brother's children to feel the love I had for them; for me, miles did not exist. There were many times during my research years when I felt a deep longing to share in their childhoods.

March is the month Mirko was born. It is the month when the Australian bottle-brush trees in Florida are in full, red bloom. It is also the month when Mirko comes to visit from Sweden. I was born in April, and Mirko in March; our birthdays are one week apart, and we usually celebrate them together in Florida.

To My Brother on his 70th birthday

*Born in late March,*
*under stars of Southern sky,*
*you learned early*
*to fly to the North.*
*Lights and shadows played in your life,*

*gazing into your soul,*
*but you were free to fly*
*like gold rays in the sky.*

*Through the years,*
*you gave me a part of your strength*
*you stretched your hands toward me so many*
*times,*
*pouring your gifts of light.*
*We shared a colorful land of joys and sorrows*
*in a world full of surprise.*

*So many unknown things*
*you made known to me.*
*In how many places*
*you found room for me.*
*Like fallen petals from multicolored flowers,*
*blossoming during your life,*
*in the wet grass under your feet,*
*I wonder what stories they can tell.*

*From the turbulent sea*
*no matter how heavy the load was*
*I knew you would reach the shore.*
*On the path we have to walk*
*will we be able to say words of contentment*
*and, yes, I think so.*

*Thunder passed and we found light*
*and strength to fly.*
*So many years had passed;*
*the colorful life of shadows and light,*
*rain had passed, a wave rose up in my heart*
*a wave of the sea far from the shore.*

*Today we celebrate your life,*
*we bow our heads for your energy and strength,*
*for the warmth of your heart,*
*and I am so grateful having you in my life.*

Your sister, Tatjana Webster, St Petersburg
March 2018

# CHAPTER SIXTEEN

ONE DAY, WHILE living in Linköping, I met a Swedish man and fell in love. His name was Johan and he was two years older than me, handsome and tall, with blond curly hair, fair skin, and ice blue eyes. He was always well-dressed, even for casual occasions. Johan was an intellectual, and he enjoyed long discussions, especially about politics and socioeconomics. He was a talented artist, working freelance jobs as an illustrator at the university hospital. He enjoyed golf, sailing, woodcarving, and furniture making. I met him at a dinner party given by friends. When we were leaving, he walked with me to my car and asked if he could see me again soon.

A few months later, I wore a white wedding dress with a train several meters long and a silver crown atop my head. I walked slowly down the center aisle of Linköping's cathedral, Dom Kyrka. My Papa and Mama came from Belgrade to be with me on this special occasion. It looked to us like a fairy tale. I added the new role of wife to my life.

As a new Swedish wife, in the early 1970s, I embraced the Swedish culture, mannerisms, and language, learning to express my inner feelings in a new, Scandinavian way. I was proud to learn not to gesticulate so much with my hands while speaking. When I was with my family in the city, we felt compelled to speak our Yugoslavian language in a low voice as we did not want to be seen as foreigners or to be called *svarta skalle*, black heads, although none of us had dark hair. Initially, as a new wife, I was most comfortable in the hospital where I felt confident and content. However, at other times, I felt I wanted to cry out in frustration over the pressures of adapting to this new role that neither Johan nor I were ready for.

Johan's family had a country house near a large lake, a half hour drive outside Linköping. We would usually go after work on Friday evenings and meet his parents there. The first time I saw the *stuga* (cottage), I thought that we were coming to a small castle. Before us was a white two-story building with six bedrooms and a large kitchen. Fruit trees and garden beds, full of flowers in blossom, were carefully placed about the grounds. It was on a small hill overlooking a lake filled with floating lily pads in bloom. There, I learned to find and pick chanterelle mushrooms in the forest behind the house. Johan would play golf at nearby courses, and I continued to study formal Swedish etiquette. Swedish manners were interesting to me, and I learned them well. The sense of order in Swedish manners fit my nature as though it was tailor-made. I enjoyed making formal dinners with different courses, wines and the use of the fine

*bestik,* (silverware), crystal and china. I still very much enjoy setting a formal table.

Johan's mother always served dinner impeccably at a large, beautifully made table that included a huge candelabra in the center. To start dinner, we would give our Swedish toast to health, *Skål,* with our wine. I learned to always look into the eyes of the hostess, partner or friend, holding their gaze before bringing my glass down from my lips. Dinner started with many kinds of fish appetizers, usually followed by a main course. Then we would move to the salon, nicely furnished with French furniture, for coffee and dessert. My Swedish father-in-law used to say, "After dinner, we can relax and talk. Let us have some dessert and coffee."

After we moved into the salon, the evening's hours would pass quickly. My mother-in-law was an intelligent woman who enjoyed joyfully provoking her son and husband. She would say, "The German mark is again very strong in Europe."

And her son would answer, "In my opinion, the Swiss franc is stronger."

All this time, I had no opinion about the world's economy. I waited patiently, hoping that the conversation would possibly turn toward music, art or literature. Usually, however, it did not. I would eventually excuse myself and go to sleep. I learned that they never talked about other people's private lives, their families, children or grandchildren.

It was summer, and Johan and I had been married a year or so, and every day was a new experience. In anticipation of the

celebration of Midsummer, I bought a new white dress with small, blue flowers. It felt light, and I was so happy because I was expecting a new Midsummer adventure. It was going to be a new discovery for me.

That year, the holiday fell over the weekend, so, late Friday evening we packed our sports car with necessities and drove to the countryside near the lake. We passed many small, red cottages surrounded by forest greenery as we went by lakes, rivers and the Baltic Sea. I was enjoying a welcomed break from the rigors of medical training at the University. We saw many houses decorated with garlands of fresh flowers and green tree branches. When we arrived at a large field, we saw the tall Maypole or Swedish Midsummer pole, decorated with fresh flowers in many colors, as well as long, blue, yellow, red and purple silk ribbons flying in the breeze. People of all ages were holding hands and dancing around the Maypole. We joined them listening to the music from the accordionists and fiddlers dressed in traditional folk costumes.

My heart pounded with excitement. In Sweden, during the summer solstice, nights are very short and days are long. People spent all night watching the sunset and the sunrise a few hours apart. Johan and I held hands and danced for hours. Then we sat on a blanket drinking wine and eating grapes and cheese. I watched the sky change colors from light blue to dark gray and back to light blue over a few hours as the sun set and rose again. Women and girls would pick seven different flowers, weave them into a wreath and place it under their pillow for their wishes to come true. I walked in the field and picked seven

flowers and placed them under my head dreaming that we should have a child. I was an innocent youth with naïve dreams and hopes that went unfulfilled. One thing was sure, I was happy to learn about the spirituality of nature, and my heart filled with optimism for new experiences and adventures. Midsummer elevated my spirit and pushed me forward to explore other unknowns.

Sometimes I would join my husband when he played golf. I would wait for him on the grass beside a lake with our dog, a Papillion named Birdie. I felt that life was good, and that it would always get better. However, fate was not done with me yet.

During my first few years of marriage, I had a strong biological and psychological need to become a mother. I couldn't explain where these feelings came from, having had a traumatic experience in the past. My husband and I could not find an explanation for our failure at the time. Physically, we were both fully capable of becoming parents although it did not happen. Maybe it was a lack of time spent together. I was assigned many nights and weekends at the hospital, and our free time was with his family and not by ourselves. I can see that more clearly now.

Time passed quickly, filled mostly in the University Hospital, spending many nights on call. The many years of medical training were hard, but I expected it to be that way. I remember in the darkness of winter, walking toward the hospital in the very early hours of the morning and coming back home again in the evening darkness with a hope that I could fulfill my home life as well as my professional life. I loved the darkness of

harsh winters in Sweden. Somehow it fit with that educational period of my life perfectly. I tried to be a good wife in every way when home and I thought I had succeeded—I was so wrong. I started to feel my husband slowly growing distant although he never openly complained. It awoke guilt feelings, which consumed my free hours without resolution. I didn't know how to improve our relationship although I felt I did everything correctly except spend more time at home. Summer came, I had a few weeks of vacation, and we decided to travel.

# CHAPTER SEVENTEEN

IT WAS THE early 70s, and Johan and I had been married a few years when we drove our blue Citrëon to the Adriatic Coast of Yugoslavia. We took the ferry to Germany, and then we drove through Austria and Slovenia, finally arriving in the northern Croatian coastal city of Rijeka. Over the previous centuries, Rijeka has been conquered and occupied by many peoples and nations. The central European atmosphere is still preserved in the majestic 19th-century buildings that we saw along the avenue, Korzo, as we and other locals and tourists strolled along the waterfront on the Riva.

The next day, we drove south on the Magistrala, following the Adriatic coastline to our destination of Dubrovnik. On the left, we could see high, rocky mountains mixed with the green forest; and on the right, the road ran dangerously close to the edge of high cliffs, falling precipitously to the Adriatic Sea. As we made our way south, with nothing but sky and sea, without barriers or guardrails on one side and mountains on the other— we were filled with both wonder and fear.

Our journey continued along the Adriatic coast, and two days later, we arrived in Split, Mama's birth city. During our drive and the nights we spent in small bed-and-breakfast hotels, I had expectations of developing a new closeness with Johan. All I was longing for was a hug, kind words, and possibly for love to be expressed. Yes, we had a physical relationship, but I wanted something deeper. I longed for shared intimate touches and exploring pleasurable feelings in our bodies. I was starting to realize that these desires would remain only desires and dreams, at least while I was in this marriage. The conversation always came around to how I had to change to become more Swedish, and how he had to find a steady job. Conversations like these damaged our relationship, and I expressed a growing anxiety that our financial situation would be unbearable unless my husband quickly found a job. Maybe I didn't want to be the breadwinner in a new relationship and have him constantly remind me I'm never home due to my job at the hospital. I know now that we became more aware of these problems as the invisible wall grew taller between us.

We went into Split and enjoyed coffee on the square by the apartment where Mama was born. We walked on the Riva and ate fish for lunch in a restaurant there. Then we continued our drive, stopping overnight, and the next day, we arrived in Dubrovnik. It had been a long journey of sixteen hundred miles from Linköping to Dubrovnik, the city where my Noné Pina was born.

We drove into Dubrovnik on a hot summer evening, and we went to a beautiful hotel on the waterfront, sitting on the

balcony drinking wine and eating grapes. Music of the night mixed with the fragrance of lavender filling the breeze, caused longings within me for happiness and closeness with my husband. A gentle touch and a kind word, a willingness for intimacy, were all I needed. Neither came my way.

In the morning, we went to the most beautiful beach I had ever seen. There were large, smooth stones in patches of white sand leading to the azure sea. We both dove into the blue waters of the incredible Adriatic Sea, and as we floated, I felt my disappointments and unfulfilled dreams drifting away. In the evening, we ate fresh lobster and were serenaded with local music on a beautiful candlelit night. Despite the beauty and serenity surrounding me, these times were difficult because my romantic expectations were high. I told myself that I had a choice to continue with this marriage or not. I continued to live with hope.

The next day we explored the city. Founded in the seventh century, the history of Dubrovnik was overwhelming. You could feel the city's sense of pride and the self-confidence expressed in their motto: *Non bene pro toto libertas venditur auro*, which means, "Liberty is not well sold for all the gold." My Noné Pina was one of those proud people of Dubrovnik. I remember how Papa would tease her about her Dubrovnik independence, telling her that she would fit in with the army as a general.

Johan and I stayed in Dubrovnik for two weeks, enjoying the beach, the restaurants, shops and the atmosphere of antiquity. Every morning, we would dive naked into the blue water

and then lie in the sun on the nude beach, where I felt liberated. I continued to long for shared intimacy, but didn't find it. In the late afternoon, after it had cooled down a little bit, we explored our surroundings, steeped in rich history. Our days continued to flow like a river, and I continued hoping to find something unknown that I was longing for.

One morning, instead of going to the beach, Johan and I walked in the hot sunshine through the cobblestone streets of Dubrovnik, looking to find some shade. He was interested in the history of the church dedicated to St. Blaise, Sveti Vlaho, who was an Armenian bishop martyred by the Romans in the third century. Several hundred years later, according to legends, he appeared to a Dubrovnik priest in a dream, warning him of a Venetian attack. Dubrovnik was saved from the Venetian invasion and Sveti Vlaho became the city's patron saint.

As we continued our walk through religious history, we came to a monastery from the fourteenth century. The Franciscan cloister was a beautiful place with twin columns, gardens full of palm trees, cypress and bougainvillea, with a fountain in the center. The walls of the fortress were in front of us as we continued walking through the city. Crossing the drawbridge and walking through a double gate, we climbed further, upwards to the top. The thick walls surrounded the old city of Dubrovnik, giving us a beautiful view of the bay and the nearby islands. After a short rest, we had espresso with a slice of lemon, as the Italians do. After visiting the fortress, we walked down to Stradun, to the shops and sidewalk restaurants. This was a popular meeting point, and we felt the vibrant spirit of

people surrounding us. We were thoroughly enjoying our last evening in the city, sitting among people enjoying life and sipping wine on one of most beautiful streets in the world. After brief stops in Austria and Germany, Johan and I headed back to Linköping. As we drove along, lost in thought, I believe we knew that our lives together would not continue. I was looking for a miracle to save us.

My life with Johan went on for several more years, and I was always trying to find the right direction, full of expectations of a better relationship. One day, we went on another trip, driving south from Linköping to the city of Västervik, where we took the ferry to an island in the Baltic Sea. Gotland is a large island with many villages and towns. Human activity has existed there for over five thousand years, and you can find traces of every civilization and power throughout history. The ferry docked at the town of Visby, and we drove off to explore. Visby was built in the twelfth century and is surrounded by a mostly intact, medieval limestone wall. We had reservations at a small hotel in town, and the accommodations were sparse. We went to a restaurant and ate pork tenderloin with chanterelle mushrooms, and then listened to Swedish traditional music of a three-piece band.

We walked on cobblestone streets, went to the stony beach, and felt that the nature of this island was extraordinary, with its many contrasting colors. On the second day, we went to history exhibitions and to see fossil collections that had been found on the island. We ate fish in another restaurant that evening, and then returned to our room with separate beds.

We stayed there for three days, and on the last day I felt a migraine headache coming on. Johan ate at a Smörgåsbord lunch buffet; I was too sick. A strange change started inside me on that island, most likely due to feelings of loneliness and the rip that I felt in our relationship. I felt insecure, and I wanted to reach out to Johan for help and understanding. I was young at the time, and I had the expectation of a romantic marriage. I hoped to share my enthusiasm in our new surroundings with a chance of togetherness. I had expectations that we could embrace each other and forget that invisible wall between us, which was growing taller and taller every day. It was not to be. My futile attempt to catch a glimpse of happiness never came, and I was constantly reminded of my failure.

We were two strangers when we left the island.

# CHAPTER EIGHTEEN

A S PART OF my medical practice in Sweden, I conducted clinical research studies that led to an opportunity to visit India, one of the oldest civilizations in the world. In 1976, I was part of a group of Swedish research doctors attending an international medical congress in India, which was scheduled to last one week. We would then have two additional weeks free to explore and discover the ancient wonders of India, as well as take a side visit to Nepal.

The meeting opened with an address by Prime Minister Indira Gandhi. We felt honored to be attending, and at the end of the first week we were all invited to a reception at the Prime Minister's residence.

The ornate gates to Rashtrapati Bhvan on Raisina Hill led to Indira Gandhi's residence, a red sandstone building with a huge copper-clad cupola.

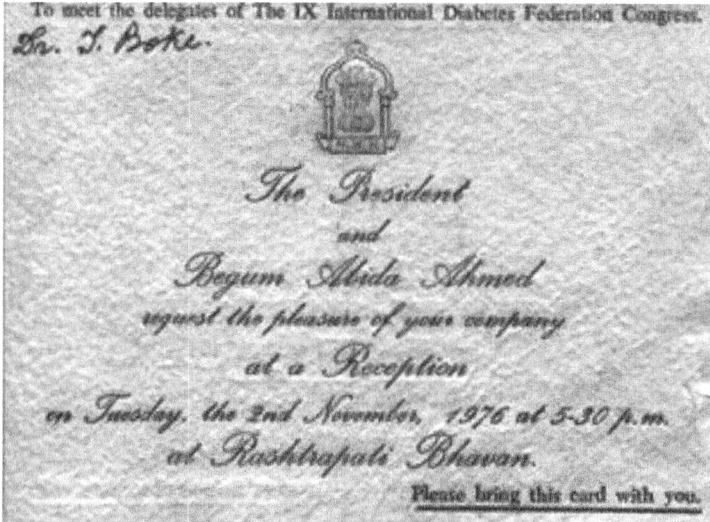

*Invitation for party at the residence of Indira Gandhi: New Delhi, 1976.*

As we passed through tall, magnificent gates, we entered into a night of fantasy. Life-sized ice sculptures of lions, tigers, elephants and peacocks stood beside brightly illuminated fountains. Indian music played in the background. We dined lavishly from long tables full of Indian dishes, fruits and desserts. It was truly an unforgettable evening. And there she was, the very powerful presence of Indira Gandhi, shaking hands with each of us. Her eyes looked directly through you into your soul, and you could not feel anything but admiration and respect for her. Somehow, my photograph of the event has been lost, yet it is still vivid in my mind's eye. My heart was saddened when later, in 1984, I saw on the news that she and her son had been assassinated by the opposition.

On one of our excursions after the congress ended, we took a bus from New Delhi to the Himalayas. We all felt the timeless beauty and eternal spirits inspired by these mountain heights. The monasteries and temples on the slopes that suddenly appeared and vanished as we drove past were an unforgettable part of the beauty. After many hours on the bus we arrived to the plateau at the base of the highest mountains in the world. We boarded a small aircraft that flew us around the massive granite peaks of the Himalayas, with the finale being a circle around Mount Everest. There was no snow on Everest, only gray and black granite. Our guide said that the glaciers we flew over were the source of three great rivers of India. The Himalayas, which formed about 30 million years ago when the continental land shift drove the Earth's crust upward, has 30 of the world's highest peaks and there we were, standing in awe of the marvels of creation.

Back from the mountains, we boarded our buses and continued our adventure to the medieval city of Kathmandu in Nepal where we stayed for two days. We visited the Tibetan Buddhist temples, and we saw pilgrims on their spiritual journeys at these centuries-old monasteries. The fascinating blend of Indian Hinduism and Tibetan Buddhism was strongly evident in Nepal. From holy lakes, marigold-strewn roads and ancient shrines, I felt that eternity and nirvana were intertwined. From what we could see, there were many people from all over the world, sitting in the lotus position on different levels of the temple and attempting to achieve an "awakened" state of mind. The legend goes that the Buddha attained enlightenment after

a long meditation period and that he spent the next years of his life teaching a path of meditation and self-knowledge so that humans could achieve the state of eternal bliss, nirvana. This Buddhist practice of enlightenment along with the rejection of materialism is followed today by millions.

The streets of Kathmandu were filled with beautiful temples, shrines covered with sculptures and erotic carvings of reddish-colored sandstone. Stepping from the bus, the festival of lights celebrating the Queen's birthday greeted us—sounds and smells led us to the brink of sensory overload. We walked through the traffic-jammed alleyways of the old town, in heat over 100 degrees, mingling with sacred cows while marveling at medieval temples and watching the people sitting on the tops of monuments.

We began the journey back to India as we again boarded our buses, which took us south until we came to the bank of the river Ganges, to the ancient Indian city of Varnasi, the City of Light—the holiest of Hindu cities where spiritual and religious history goes back more than 3000 years. We passed many sacred Ganges cremation "*ghats*" along the riverbanks with their surrounding temples and shrines. We could see burning remains and people kneeling, chanting mantras in the hope of reincarnation. The devout believe that the waters of the mighty river Ganges washed away human sin. We witnessed a sea of humanity flooding the city with thousands of Hindu pilgrims arriving daily to bathe, offer prayers and cremate their dead, with the ashes carried to eternity by the holy waters. Varnasi is called the eternal city, where religion is part of life. Saints, poets

and pilgrims have been drawn there throughout the ages. Behind the riverside *ghats* are bazaars, where we saw people in colorful clothes and holy cows roaming about. With the smell of saffron and food in the air, we continued our journey back to New Delhi.

We stopped at the Taj Mahal in Agra on our journey of several more days back to New Delhi. Our guide led us to one of the most famous places in the world, a beautiful testament to undying love, which is cherished by millions. He showed us where people sat on the edges of large fountains at the entrance where at sunset we watched the remarkable play of light on the marble of the monument. We heard the history of the Taj built in memory of the beautiful queen, Mumtaz Mahal, who died in childbirth. The bereaved Mughal Emperor, Shah Jahan, erected this mausoleum in memory of her extraordinary beauty and his undying love for her. It is truly one of the wonders of the world.

When we returned to New Delhi, we went to the Tomb of Mahatma Gandhi in Raj Ghat. There were garlands of yellow-orange marigolds covering the black granite platform inscribed with his last words: "He Ram" or "Oh God." We took off our shoes and walked over the carpet of marigold flowers. We had arrived in New Delhi during the week of the Elephant Festival. There were beautifully decorated animals parading in front of the hotel, and I took my first ever elephant ride, sitting high on the elephant's back and slowly walking through the streets. There were so many contrasts in India existing in perfect harmony; a cart with an ox pulled its load of goods down a street beside the newest luxury hotels. The younger generation was in

jeans, with older women wearing traditional saris of many colors.

The next day, we continued exploring the city. We saw ragged people of all ages sitting on pieces of torn, faded carpet, with empty eyes and expressionless faces. Some families were eating from little wooden bowls filled with rice. Piles of garbage were right beside them, and they didn't seem to notice or care. This was life on the street in the outskirts of New Delhi. There was no privacy on those streets. They took care of their basic needs right there on the corner, cleaning themselves with an old glass bottle of water, and life went on. There was not enough shelter to go around, with many people living, giving birth and dying in the streets. Children were playing in the dry, dusty dirt near the tents. The odor from human excrement was very strong. We had to jump across or walk around so much of the filth that filled the street. Fortunately, we all had high Swedish wooden shoes. Even as our hearts went out to these poor, unfortunate people, we felt totally powerless to change their condition. There seemed to be no end to the misery.

Where we were, tomorrow was a word not often heard. People lived for today, just trying to survive. Many would not endure long, and their bodies would burn along the banks of the Ganges. The streets were full of many tiny, malnourished babies in their mothers' arms, tears running down their faces. Children were running after us, begging in their language for food or money. Some women had metal bracelets and what looked like jewelry around their ankles and arms. Their clothes were old and worn. They managed the family's meager resources by

having their entire wealth worn on the woman's body. There were small fireplaces in the earth where the most fortunate families cooked chicken. They had to boil all the water that was consumed to prevent dysentery and disease. Life was hard. We all felt guilty coming from a country so clean, and having more than the basic necessities.

We would see nearly naked people sitting and eating in circles around a fire, and wondered how they survived cold nights without a roof over their heads. Women carried clay jars to the distant water wells or to the river. Their cooking pots were darkened with oil, covered with crusted flakes of wheat and grains of rice.

We could hear jingling bracelets on the arms and ankles of women; we could see yellow-reddish designs on their palms and foreheads, inscribed there to praise or please gods and goddesses in addition to their mantras and prayers. We passed Shiva temples. There were other places for what I thought must be different gods depicted in a bewildering array, ranging from anthropomorphic symbols and shapes to exotic half-human, half-animal representations. Each god had a specific power.

The overwhelming odor of dust, urine, flowers and jasmine incense mixed in the hot air. There were streams of colorful people and animals that paraded by. Crimson-shirted porters carried heavy loads; men pulled rickshaws; cars drove around slow-walking cows, while other cows rested in the middle of the street; and elephants, dressed in red costumes, wandered about. The sounds of the city were a mixture of chanting from the nearby temple where people were sitting in search of nirvana,

mixed with cows mooing, and occasionally hearing "Ram Nam Satya Hai," the mantra for people carried to the cremation *ghats* on the Ganges. All of this together formed an unforgettable scene.

We took photos of the red sandstone citadel built in the early 16th century, the Lal Quila, or "Red Fort." Then we went to a small theater where they played music that felt like it was probing your soul, combining worship and a joyous celebration of life with sensuous dance movements. The artists created a mood that invited the audience to participate. We stood, swaying our bodies, arms and hands in the air, in time with the music and dance. The performance was a celebration of natural joy and it was unforgettable.

Suddenly, during the performance, I noticed a tall man with piercing eyes sitting in the opposite row of the theater. He came over to our group during the intermission, looking directly at me. Maybe we had all been influenced by the magic of the performers and the music. At that point, I didn't know whether or not he was attending the same conference.

When the performance was over, we went back to our hotel. At a cocktail party that evening, the man with piercing eyes was standing just a few feet from my Swedish group. He had blondish hair and was wearing jeans and sneakers. His badge said that he was a doctor from the United States. He approached me at the end, when everyone was leaving.

"Hello, I am Dr. Horne, from Philadelphia," he said. "Did you enjoy the theater performance?"

"Yes, I did," I responded.

Then he started talking about his medical practice and his hobbies, which were running and traveling. I could feel the intensity as he talked. I looked at him, listening to the words pouring from his mouth with great speed. I was immensely pleased with myself that I could understand almost every word and I felt that all of life's possibilities were within reach.

He said, "Well, I'm not married. I've traveled to South America, Germany and Spain, but never to Scandinavia," although I hadn't asked.

"I'm married, no children," I said, wondering why I mentioned children. I suppose I felt that he wanted to learn more about me.

He suggested that we have dinner together the next evening in a nearby restaurant. I accepted his offer, mostly due to curiosity, or perhaps to test myself. At the restaurant, we both laughed when the food was brought and no silverware was available. We washed our hands and ate food with our fingers. I remember I was thinking that I had invested so much in my hopes and dreams in Sweden. Suddenly, he asked, "Would it be possible for you to come to Philadelphia to visit and stay with me? We will have time to learn about each other better."

Clearly, he didn't pay any attention to the gold ring on my hand.

"My father is a professor at the university," he continued, "and can help you with a work visa."

I could not believe what he had just said and in such casual way. There is a Swedish word *snopen* (pronounced snoo-pen), which means "shocked and surprised." That describes my re-

action exactly. After I recovered, I talked about my professional goals in Sweden and said that I was not looking for a new relationship. After all, I was still married, although my husband and I felt our marriage was breaking apart.

He said, "If you change your mind, let me know. I would like to know you better." Then he gave me his address in the United States.

I was surprised and enchanted that life could offer me opportunities for enjoyment. I was fully aware that I was not ready to accept them. I was so young and naïve. It was my first encounter with an American man, and I never saw him again.

When I was fifteen years old, I had read an ancient book of poems written by the Indian poet and composer, Rabindranath Tagore. In 1913, Tagore was awarded the Nobel Prize in literature, so there was a Swedish connection. (He was the first non-European to achieve such an honor.) He died before I was born, yet his poems transcend time and place. I loved his writing and his description of timeless life, but then I forgot his work for a while. Eighteen years later, I found myself with a strange feeling that I recognized and knew already about part of India's beauty and what life there was like. In Belgrade, at fifteen, I didn't quite understand his work, but I felt I had found a deep treasure for my soul. But, while in India, I began to understand some of the complexity of his country, culture and art in his work.

# CHAPTER NINETEEN

WHEN JOHAN AND I had first married, I thought that we had an idyllic life. I worked, and on many weekends, we had time together with his parents in their country house, and we generally led a gentle life. Then, one gray, cold day in November in the late 70s, my world came crashing down. It was Friday, my workweek was over, and Birdie, my doggy, and I were waiting for Johan to come home. Dinner was prepared, there was soft music in the background and candles were lit. I thought that it would be a perfect evening.

When Johan arrived, he calmly said, "I've made my decision. I'm leaving you."

"What did you say?" I asked, stunned.

He repeated, "I'm leaving you."

The beauty of this evening together suddenly evaporated into heartbreak. I still could not believe that I had heard him correctly.

"Why?" I asked again. "Why?"

No answer. Birdie barked at Johan, so he went to another room and closed the door, and then there was silence.

I stared at Birdie and said to her, "Maybe he is going on a trip. He will be back."

She looked at me and barked again.

As if in a trance, I blew out the candles, put the food in the refrigerator and then I took Birdie out for her walk. It was then that reality hit me. A flood of tears blurred my vision. I forgot the leash, and my dog ran across the street. I wore contact lenses, and my vision was blurred with tears. I couldn't find Birdie. Panic began rising inside me. I was losing both my husband and my dog.

Then my neighbor, Brigitta, approached me and said something about her concern for me. I was standing there on the pavement, obviously distressed. She asked, "What happened?"

"I've lost everything," was all I could say through my sobs.

Brigitta somehow found my dog, but I never found my husband. When Birdie and I came back home, the apartment was empty. A month later, he came back and started placing labels on furniture that he thought belonged to him. He placed a label on Birdie and took her with him. I didn't know who I missed more, my dog or him.

This was the man with whom I had lived, the man who had been my husband. We never had enough time to learn about each other. Sometimes I grieved for what was never spoken. Looking back, maybe he felt he was in my shadow, and I was too scared to express my deep feelings. Perhaps he felt insecure with

a woman full of ambitions. Or maybe we were just two different people with two different lives who were simply destined to be together for only a short amount of time.

# CHAPTER TWENTY

TWO YEARS BEFORE I left Sweden, when Johan and I were just divorced, Papa traveled from Linköping to Germany on a business trip and, from there, took a short visit to Belgrade. At that time, he was still working at Narodna Banka Srbije in international business. He called Mama when he arrived in Belgrade, complaining of stomach pains, and he reluctantly went to the University Hospital and was told to return if the pain got worse. He never did. He had been told that it could be "stomach problems," and that maybe it would heal on its own. This was before CT scans and the medical procedures we have now.

Later that same day, he died alone in our old apartment on the fifth floor. On the second day after Papa left Sweden, after dinner Mama and I were at home in Linköping, when an unexpected phone call came that shattered the night. Belgrade informed us of Papa's death. The autopsy showed that he had died from a ruptured abdominal aneurysm.

Everything was black around me. Later, I learned that Mama had fainted. The whole world crashed down upon all of us. I remember that I was given a sedative, a very small pink pill, before leaving on the train for Belgrade with Mama and Johan, who wanted to join us. Adding to our distress, Mirko could not travel with us because he had left Yugoslavia before he had completed his obligatory military service. He felt the devastating loss of our father and the added sorrow because he couldn't attend the memorial. It was many years before he would return.

I recall walking behind Papa's casket, which was covered with green wreaths and flowers, in a procession of more than three hundred people. I heard military band music as we walked along. Even with a crowd of many people giving Papa their last respects surrounding us on this cold, gray, cloudy November day in Belgrade, I felt all alone. Papa's final resting place was with my Noné Pina in the cemetery on a hill overlooking the city. Again, I was confronted with the end of life.

While the casket was slowly lowered into the ground, a bright ray of sunlight suddenly appeared between the clouds on the far horizon of Belgrade. In that unforgettable moment, I had a strong feeling that his soul had left us forever. I felt powerless, sadly aware of the failure of my profession to save my father. I couldn't remember him ever being sick in his entire life.

Upon returning from Belgrade to Sweden, Mama's beautiful eyes often filled with tears, yet she had an extraordinary strength, both physically and emotionally. At that time, she was

in her mid-50s. Life had to continue, and Mama cared for my brother's two beautiful girls while Mirko and Ann were at work.

I didn't return to Yugoslavia for 52 years. I thought that if I saw our old home on Boulevard Revolucije, I would probably not be able to go inside. Memories about my father's death were too strong. The pain was still within me. I have a very good friend in Belgrade who visits his resting place a few times a year and brings flowers, and that provides some comfort.

# CHAPTER TWENTY-ONE

DURING THE YEAR after my divorce, Mama needed some distraction from my almost daily complaining about my feelings of misery. One day I saw a newspaper advertisement for a weeklong trip to London and made reservations for us to go. We drove to Stockholm's Arlanda Airport and boarded a Delta flight and after a couple of hours, we landed at London Heathrow. We cleared passport control without any problems and then caught a taxi to our hotel in the center of the city.

We felt like two young women full of high spirits and expectations for a new adventure. Both Mama and I travel very light and in no time, we unpacked and were ready to explore the city. The early summer was warm, the trees rich with new green leaves and the gardens around the houses were full of blooming rose bushes. The streets were brimming with tourists, and we started walking, holding a map of London in front of us.

We decided to visit Buckingham Palace, the British monarchy residence. As we boarded one of the famous double-

decker buses, Mama and I had high expectations of looking inside the palace and seeing whether it was like the pictures we had seen in magazines. When the Queen was not in residence, visitors were allowed inside for about two hours per day. That day, we could only look at the palace from the outside. The royal flag was flying from the building's roof, meaning that HRH (Her Royal Highness), the Queen, was there.

We did get to watch the parade of bearskins at the Changing of the Guard, the daily palace ceremony with bright red uniformed regiments marching to the music of bagpipes and drums. The high bearskin hats nearly obscured the guards' faces. Their costumes amused us, and we were in awe of the pomp and circumstance of the parade and ceremony. We were among many tourists, mostly Asian, and all of us held cameras in our hands, standing in front of the high gates of Buckingham Palace and peering at the expansive lawns and gardens that lay beyond.

From there, we walked across to the southern side of the park, known as "Birdcage Walk," which led us to the Big Ben Clock Tower and Westminster Abbey, with its historic Gothic towers. I was so happy and excited, pointing out St. Thomas Hospital in the distance, across from the House of Parliament, where I had finished part of my medical internship. When daylight was fading, we found a cozy Greek restaurant on Princess Street. We were shown to a table and ordered a wonderful meal. Greek musicians played lively tunes, and one of the waiters started throwing plates on the floor, shattering them when they hit. We were encouraged to join in. About ten plates were given to each of us to break on the floor in what we began to

understand was a Greek ceremony. Mama stood up and began breaking her plates, a wide, mischievous smile on her face as we joined in enthusiastically with those around us. This was a very happy time, and a memorable moment of our visit.

The next day, we strolled through Hyde Park and then sat on a bench near a lake, eating pastries and feeding the birds, which were mostly ducks and swans gliding on the surface of the water. These were days of complete happiness, a release from the emotional stress after my divorce. I was hoping that Mama would forget the daily complaining she had endured at home. One week later, as we left London, I promised myself that my complaints were not worth Mama's time, nor mine. People usually tell you that time heals emotional wounds. Maybe they're right. To this day, I carry visions of Mama and me sitting together in the park, a lovely memory.

# CHAPTER TWENTY-TWO

OUR RESEARCH GROUP was invited to present our work with prostaglandins (hormone-like substances that involve many body functions) at an international conference in Washington, D.C. I submitted a poster presentation that was accepted, and I was able to get sponsorship for my expenses. About 20 others in my group either had presentations accepted or were invited as speakers.

We took long Delta Airline flights to the States; the crew served us breakfast, lunch, and dinner, and then breakfast again. As we approached the airport outside of Washington, the mood was building with excitement and eagerness to finally arrive on a new continent and to see the capital of the United States. Anticipation for a new adventure was high.

After landing, we took buses from the airport into the city and checked in at a very nice hotel. The presentation of our research began in a grand ballroom the following morning. Our Swedish group presented new approaches for the role of prostaglandins in the treatment of wounds. There was a lot of

interest in our findings among colleagues from all over the world.

One evening, we were all invited to a reception in the Capitol Building, where I mingled and chatted with other researchers. We found that our American colleagues were surprisingly forthcoming in their discussion about research. We were not accustomed to open discussions of that kind. Back home, in Sweden, people didn't talk much outside of their group. Still, our work and advances in science were celebrated, which was very gratifying.

I was standing with an attendee from Texas and another from Ohio, discussing our research, and both commented that they had been to Scandinavia for conferences, noting how English was frequently spoken there. Someone from Memphis, Tennessee, came over and asked about my research and background. When I said that I came to Sweden from Yugoslavia, he said, "Oh, you were not born Swedish?" and then he started speaking enthusiastically in Serbo-Croatian about Belgrade. He had received several of his Ph.D. degrees in Yugoslavia, in Zagreb and Sarajevo, before continuing his research work in Canada and then in the United States. He was originally from Pakistan. He added that he had seen my poster, and we discussed some of our mutual research in the same areas. I didn't know it at the time, but this man would become my mentor as I took yet another leap into the unknown.

Later on, I met another prominent professor from the Cleveland Clinic who was also interested in our prostaglandin research, and he offered to arrange a meeting in Cleveland,

hoping that I would come for a fellowship and continue my research with dogs. This was a negative for me because I love dogs. It was easier to work with white rats.

Then a man I later learned was highly placed in medical education approached me. He was distinguished and well-dressed, and he spoke in a low voice as he asked me whether I was considering starting a medical career in the United States. And, if so, he volunteered to help me. At that time, I had not looked at the requirements for approval to practice medicine in the United States, and I didn't know the procedures for foreign doctors; thus his question perplexed me. He added that he would help with legal issues only under the condition that I would visit him in his country house outside of Washington, D.C. I felt indignant at the implications of his suggestion and curtly told him "thank you" before walking away.

On my last evening in Washington, D.C., I was at another reception at the Capitol Building and ready to call for a taxi back to the hotel. One of my female colleagues from Oregon, who was staying at the same hotel, told me that we did not need a taxi. She said we could just walk the few blocks. It was her country, and I felt that she would know more about the environment than I would. I made a huge mistake accepting her idea.

We had walked less than a block beside a large fountain on the Washington Mall, heavy traffic on one side of the road and a park on the other side, with us in the middle, when two short men suddenly came toward us from the park. One tried to steal my purse and the other grabbed her camera. The woman from

Oregon started hysterically crying and took off running, with one of the men running after her. I was using all my might to keep my purse, and fell on the pavement, scraping my knees, but I was still holding on to the purse for dear life. Although I was scared out of my mind, I was ready to fight. Then suddenly a third man appeared from the park speaking Spanish to my attacker, who fled immediately. Traffic was heavy, yet no one had stopped to help us. Later, in the hotel, we both reported the incident to the police, and as I expected, no further action was taken. The next day, I flew back to Sweden and had a lot to report both good and bad about my first experiences in the promised land of America.

My life as a Swedish doctor continued without interruption until one day I received a letter from the Cleveland Clinic's head of the Nephrology and Research Department, and a few weeks later, a second letter arrived from the University of Memphis in Tennessee. I had met both parties during my visit to Washington, D.C. Each offered me research opportunities of the kind that I had been dreaming about since my work in Great Britain, and both men were well known in their fields, with numerous publications to their names. I was again at a crossroads of the unknown. I knew that I was experiencing a very exciting time in my life.

It took me a whole year to make up my mind to leave Sweden for what I thought would be just a two-year fellowship offered by the American Heart Association. Sometimes I feel that I ran from a life of safety and happiness where I had succeeded in my professional life, held a well-paying position

and was close to family and friends—I could not explain the pull of the unknown. When you achieve success, you begin to think everything will be easy. I needed to learn more.

# CHAPTER TWENTY-THREE

I MET HIM at a time when I was ready to live out my fantasies, ready to believe in love, and ready to dream of happiness. Christian was his name, and now I look back and see that love came to me unexpectedly. Maybe it was a love story, or maybe it was because I had time to heal after divorce.

He was an engineer from Copenhagen. I attended a medical conference in New York, and we were both staying in the same small Manhattan hotel. During breakfast, our eyes met across the room, and a spark of unexpected happiness took flight in my soul. I first saw tenderness and kindness in his face and eyes. He was tall, with dark, straight hair and deep, piercing eyes. He smiled at me. We greeted each other with "good morning" in English, and asked about where we each came from. Our English foreign accents betrayed us, and we discovered that we were neighbors by country. We did not speak exactly the same language, however; so we chose to talk in English. I found out he was at an engineering conference. Time was short, so we made plans to meet later that day.

After a few hours of listening to medical presentations, I met Christian in Central Park near a lake full of birds. It was autumn, and the trees were bare, with brightly colored leaves carpeting the ground and the lake surface. I felt a strong attraction and was drawn to him intellectually and emotionally. Frankly, these feelings scared me. It had been a while since I'd shared time with a person of the opposite sex. Sadly, I had to leave the next day, heading back to Sweden, and he was to return two days later to Denmark.

Christian called me in Sweden immediately after he returned home, and he wrote soon thereafter. We talked on the phone for several days, and soon we were meeting on the weekends. During that last year in Sweden before coming to America, I would often meet him in Copenhagen. His house, which he designed and built, was on two levels, surrounded by a garden and pine trees. It all blended beautifully with the surrounding nature. The paneling on the walls gave off a forest fragrance, permeating the air throughout the house. I traveled from Sweden to be with him, sometimes by car and sometimes by train. He talked frequently about our future life together.

The final year of living in Sweden was troubling for me; once again, I was at a crossroads. I was not ready to begin a new life with another person. I felt tossed about in a turbulent, unknown sea, sometimes on an island with a storm raging around me. Our last times together in Denmark were very difficult. I could not refuse the research project offer in America. It was supposed to be short-term, just two years, after which I could return to Scandinavia and to Christian.

He promised a life together and begged me to stay. I left for America, and a few months later, he came over for a visit. He stayed a week, mostly by himself because I had little free time available, and he soon left.

Being with him was like living for short periods of time surrounded by soft walls of sunlight, happiness and desire. It was a time of healing and self-discovery, something new in my life. I will always be grateful for our time together. We went for long walks along the shores of the Baltic Sea, made no demands on each other and were not afraid to express ourselves in a way I never had before.

In those days together, I found a new sexual intimacy, which led me toward self-discovery. It was pleasurable. However, the earth didn't move as I'd heard it did. That was to come much later. I had reached a milestone, a long way from my first attempt with that unknown experience in Kalimegdan Park. Maybe I was taking more than I was giving. I hope we both enjoyed the journey of my awakening and the process of healing.

Christian once took my hand and placed a small, gray, shiny stone that he had found on the shore in my palm. He told me, "We will always be connected, regardless if we are together or not." I knew somehow that we would not be together. At the same time, I felt like I was never closer to anyone than at that moment in my life. I couldn't yet understand how these feelings could both be true.

I was with another person who said that he loved everything about me, but somehow I could not reciprocate. I was afraid that what I would say would hurt him. I was living in

a cocoon of soft happiness, desire and sunlight shining into my soul. No relationship had ever been like that. We shared a connection while walking along the edge of the green forest near his home. There was a complete acceptance of each other, no fear of expression. And yet I wasn't ready to give myself over to him completely.

One day I was in Copenhagen, sitting in his garden and looking at the ground covered with green moss. As the day ended, and as the color became gray-blue, the garden would become a prison of my insecurity. Even then, I was longing for other unknown places. I never told Christian the truth about my feelings. At the same time, I felt like I never was closer to what I wanted in life. This time spent with Christian was showing me what I was longing for. The last time I saw him, he had tears in his eyes and expressed deep feelings of betrayal. The roles were reversed this time, as I was the one leaving.

I had an uncertain future, combined with a sense of excitement that frightened me or, maybe it was the fear giving me excitement. These thoughts did not come to me then. My future was white rats, laboratory and research papers, and then I would return to Scandinavia or so I thought. However, life would take me in many other, unexpected directions, which I did not realize were possible at the time.

Christian visited me after I moved to America, two or three times per year for the next five years. Then he never came back. After one of his visits, the girl inside me wept and wept. She was alone and there was nobody to dry her tears. One day I had no more tears left, and I realized that I had made my choice.

At that particular time in my life, I felt like a boat floating on stormy unknown waters, the excitement and fear filling me and keeping me going. There would be time later to have a family life, maybe a child. For now, I would choose my career and the fulfillment of my research dream that had begun in England.

Many years later, I called Christian to apologize for the enormous amount of pain that I had caused him by my refusal to commit. During my time with Christian, I did not want to analyze the reasons behind my fear of commitment. Maybe a small girl's fear lived inside of me. I could not trust someone else completely, not yet.

# CHAPTER TWENTY-FOUR

AFTER MY DIVORCE I was still living in Sweden feeling betrayed and depressed. I wanted to change the course of my life, and I wrestled daily with guilt and with feelings of personal failure. Was the answer another unknown step?

While I was searching for answers, a letter arrived one day from Bern, Switzerland. I had continued phone contact with a friend from our group of fifty-six doctors from Yugoslavia. A few years after we arrived in Sweden, he and his family had left for Switzerland. He confided in me that his wife was too depressed to live in Sweden. He had news: an older internist in Geneva was retiring and selling his medical practice. Immediately, I thought that my French language would serve me well there. Maybe my unknown answer would finally become known.

Contact with the Geneva internist was established, and he offered an invitation to visit and discuss the opportunity with him in person. I asked Mirko and Mama to go with me, and we

drove south from Linköping and boarded the ferry taking us to Lübeck, Germany.

After a night in a small bed and breakfast, we were on the road again, and after presenting our papers at the checkpoint, we entered Switzerland. We arrived in Bern a couple of hours later, where we met my friend and his family. He was a neurologist there, where he and his family had a happy life and were only two hours away from the old country. He said that they had found contentment in Switzerland.

We stayed with him for a day before traveling to Geneva. We checked into a hotel near Lake Geneva, and the next day we drove to the internist's small hospital and his office. We talked as he showed me around and gave me a written offer that he had prepared before I arrived. I remember that I had his offer in my hands for the rest of that day. I couldn't believe that this opportunity was real. In the morning, after barely eating anything for breakfast, I still could not make a decision. This was the time of my life when very different pathways opened up to me almost simultaneously. On one hand, I had the research offer in America, and on the other, there was this offer in Switzerland.

There were different thoughts that started building inside my head. I felt fully confident about my medical skills and with speaking French. On the other hand, I had no experience managing a private office; I had always worked for a salary. Where would I get the money to buy his practice, and where would I live? And I knew that living in Switzerland costs more than living in Sweden. Something else, not really a conscious

thought at the time, was floating around in the back of my mind: Why was he so eager to sell without negotiation?

The unknowns, this time, would not win. In the end, I thanked the internist in Geneva and told him I needed more time, and then I left for Sweden. A week later, I wrote him a letter, declining his offer. Perhaps my research dreams and plans were an illusion, but they were less of an unknown, and I could see opportunity in the United States. There, I knew that my drive would bring me success. I needed real success to help overcome the pain of abandonment, betrayal, and death. I needed more stimulation at the time, or so I thought. I felt emotionally starved because of the difficulties, and I had no understanding of what was at the heart of my unease about myself and my situation. I was unsure why I felt so totally powerless. Then I realized that I had felt completely rejected and discarded following my divorce, so I supposed it was time for me to find something else, something far away.

After my divorce, while still trying to figure out my new direction in life, I was in Vadstena, a small city near Linköping, walking alone along the edge of Lake Vättern. I was looking at what appeared to be an endless and bottomless lake with dark, gray water. Under a cloudy sky, I touched the weather-beaten trunks of the trees as I passed. They reminded me that I was still alive. I sensed dangerous the water beneath the surface, reflecting the disruption I felt, pulling me from my surroundings. The last flickering of daylight was reflected from the flat rocks at the edge. There would be no sun for the next several months of Swedish winter, this fit with that time of my life. The winds

were getting stronger, driving the waves and giving their white tops a lacy appearance. Here was my refuge, where I tried to find the answers to so many questions.

In Sweden, I was a well-established medical doctor with many credentials and a specialization in nephrology. I had worked hard to reach this height. Could I reconnect with my former professional life after two years abroad? I thought about my colleagues who went to the United States for a short time and recognized that their experience abroad had enhanced their careers. I was pulled in by the intrigue of pure research.

That day, in Vadstena, I found an answer to my doubts about going to America, thinking that it would only be for a short time. I was so wrong. The unknown was once again waiting for discovery.

*Sometimes, I would leap*
*into the ocean of my desire.*
*Sometimes I would dive in the unknown fire.*

*Sometimes, I run to a wall*
*not able to see my goal,*
*blinded by my desire.*

*In love, in life, in light of the soul*
*I saw visions of my goal,*
*fading sometimes away.*

*My desire blossomed out*
*like a wild flower.*
*I reached to pick it.*

*As it flew away,*
*my soul flew in the sky*
*when sun was fading on the horizon.*

*With my desires I will make a garland*
*full of wild dreams*
*floating out on sea streams.*

Tatjana Webster, St Petersburg
November 2017

# CHAPTER TWENTY-FIVE

IT WAS A very cold day, late in November 1979, when I boarded the plane in Stockholm. Eighteen hours later, it was 86 degrees when I landed in Memphis, Tennessee. When I left Sweden, a part of my life's journey was behind me forever, though I didn't know it at the time.

My mentor, a professor who would play a crucial role in my research years in Memphis, greeted me at the airport. We went to his home, where I would live with his family for a few months while I waited for a dormitory room to become available. I met his family and unpacked my books and journals from my two suitcases.

The next day, we drove to the laboratory, which was thirty minutes away, where I was introduced to our small research group. It was an international team: one person from Japan, another from Turkey, another from North Carolina, another from Pakistan and me. I worked in the laboratory every day except Sunday. My mentor told us that we should not lose time in our quest for new scientific findings, and that a fellowship has

a definite ending. Work not completed now, never would be. Three months later, the university found a dormitory room near the research laboratory, and I finally had my own place. As it happened, I saw very little of it because there was so much work to be done.

My first assignment was to become familiar with the research animal housing and the procedures for animal welfare. Then, the next week, I learned to anesthetize my research rats, and I performed delicate kidney surgery in carefully controlled experiments. I would collect blood and urine every day for analysis. We were trying to identify the enzymes that regulated blood pressure and were in a race to find them because that would lead to new treatments for hypertension. Dr. Malik's group published many research papers and we presented our findings at scientific meetings throughout the country. After three years, I presented my findings to a group from the American Heart Association. This led to funding for another two years. After years of doing research on rats, I realized that I still felt unfulfilled and missed contact with patients. My research years satisfied an unknown that I had been curious about and helped me to realize who I was: a medical doctor dedicated to helping others.

# CHAPTER TWENTY-SIX

O N THE WEEKENDS, in Memphis, I began to slowly build a social life. I worked daily in the research laboratory and lived in the student apartments. One day I got a phone call from the university asking me to translate a paper written in Swedish. I met Elisabeth, a woman who worked part-time in administration. She was in her 60s and took me under her wing, thus beginning a long friendship. Elizabeth's mother was Swedish, and that was a strong connection. She introduced me to people at the Unitarian Church and to the culture and customs of my new country. Elizabeth guided me while I navigated my new life, and her presence eased my adaptation. She showed me where to find lutefisk, pickled cod fish, which was in the imported area of the grocery store. I may have been the only person who bought it. Frankly, I did not especially like the taste, although I ate it to remember my Scandinavian culture.

I was sometimes invited to restaurants that I could not afford, and I would always pretend that an appetizer would be

more than enough for me. It was a difficult time to be poor, living among people who wore different clothes every day. Coming from Sweden, I never used makeup or cosmetics. In Memphis, almost every woman I saw had a beautifully made-up face. It seemed artificial to me, and then, a few years later, I learned to make myself up in the same way.

I had arrived in America with only two suitcases full of books and some clothes. I came from Scandinavia, where the "natural look" was desired and where clothing was worn primarily for warmth and protection from the elements. Slowly, however, I learned that appearance had importance in my new society. I felt that I would never be accepted unless I learned the Memphis style and culture. Longing and loneliness were my constant companions.

I began to adapt to the rules of my new life. In Europe and Scandinavia, holding both your fork and knife while eating is proper etiquette. In the United States, however, it is the opposite. Sitting in restaurants, I was asking myself what was happening with everyone's left hand held under the table. While they were eating, these people looked happy and satisfied and didn't pay any attention to me when I held my silverware in both hands. Freedom is expressed in this country in many aspects of life.

I felt guilty about leaving my family behind. Somehow I knew that one day things would change for the better and that I would find the answer to another unknown. Many times I was afraid that I would lose my soul, my identity as a person, in a storm of cultural differences around me. That didn't happen,

and a strong belief in my abilities from early childhood carried me through this period of adjustment to my new life.

# CHAPTER TWENTY-SEVEN

MAMA READ AN article in the popular Swedish magazine, *Hänt,* about a doctor living in Palm Springs, California. She recognized his name; Danilo, my classmate from Belgrade—Mama mailed a copy to me. I remembered him well. He was my competition during medical school. I called Palm Springs information and they connected me with his office. He called me back and was happy to hear from me after all these years and invited me to visit him in California insisting on sending me flight tickets laughing, "I know you are in research and cannot afford to visit." Danilo had come to America several years after I left for Sweden. After his post-graduate training and specialization in the United States, he became a well-recognized plastic surgeon, with offices and surgical suites in both Beverly Hills and Palm Springs. His house was on a hill, next to Bob Hope's, in Palm Springs.

He met me at the airport in Palm Springs and opened the door of his Rolls Royce for me.

*My school mate from Belgrade met me at the airport in his Rolls Royce with a private chauffeur: 1981.*

I had never seen this kind of car before. I entered feeling like royalty and hoping that nobody could hear my hungry stomach rumbling. I was offered a glass of champagne while his chauffeur drove. I couldn't believe that such luxury was possible for someone from our old, poor country. Ordinary people did not live in Beverly Hills or Palm Springs, only celebrities. I saw mansions (to me, they looked like the small castles I had seen in Sweden) surrounded by lush landscaping, palm and orange trees everywhere. Then we came to his garage, where I counted at least ten more very expensive cars, including a Bentley and a Ferrari, which he offered me for use while I visited. I chose to drive his Porsche instead.

His house was built into the side of a natural hill in Palm Springs. The entrance was magnificent, with a carved wood and metal door. After I came in, I saw a large terrace looking out onto the desert. His living room was a huge open space with a swimming pool. In the middle of the pool was an outside glass wall that would raise and lower by remote control. He told me that a movie was filmed here. President Reagan and his wife, Nancy, had visited his house. On the walls there were many pictures of Danilo with famous people. And in the middle of the living room was a large glass elephant with golden tusks, a gift from the wife of a very prominent Republican politician in appreciation for her successful plastic surgery.

I went to a bathroom, and I could not find the commode anywhere. Embarrassed, I had to call his maid to help. Turns out, you pressed a small button in the marble wall (that I had not seen) and the commode would glide out for use. Then you pressed the button and the commode would disappear.

I was shown to a room the size of my entire apartment in Sweden, with the largest king-sized bed that I had ever seen. I slept alone all night hidden among silk sheets.

The next morning, my friend invited me to follow him to the office and surgical suite that he ran with two other doctors. I saw faces covered with white bandages, eyes full of fear and pain after surgery, and mouths sipping liquid through a straw. Some of his patients learned to apply Danilo's own brand of make-up products before leaving incognito to their homes. I overheard phone calls from famous people making appointments for surgery at his office. My friend had now

achieved success beyond belief. After about a week, he made an
offer for me to open my own internal medicine office next to his
surgical suite. He told me that he would help me with the legal
papers.

I was tempted to exchange my soul for fame and
admiration. They say that if it sounds too good to be true, then
it probably is. It all felt so unreal to me. I thought that I should
finish the research path that I had started, and I had strong
feelings of obligation to my mentor. Many times later in life, I
had my doubts about whether I had made the right decision, but
it would have been a huge gamble. I didn't have the proper legal
papers, and there was no assurance of a position, just a promise.
I made the right choice. So, maybe I chose the poverty of
research instead of a lucrative career in California, but
ultimately I wanted to succeed on my own terms.

My heart told me that the subsequent emptiness would be
enormous for those who chose fleeting glory and fame. The
loneliness would be unbearable, so they would seek comfort in
many other ways and places. That was my first impression of
Beverly Hills. Beautiful, surgically enhanced faces covered with
make-up could not compensate for a woman's search for
acceptance and happiness. Many years later, I heard that my
classmate left the United States and went back to Belgrade. I
wondered if he would ever find his place of contentment.

Later, I learned Danilo was hugely instrumental, working
with President Jimmy Carter, in bringing peace to the Balkans
and an end to the war. Danilo used his skills to help heal the

physical and disfiguring wounds of the victims of his war-ravaged country. I hope to connect again with him soon.

# CHAPTER TWENTY-EIGHT

M Y RESEARCH YEARS satisfied an unknown and helped me to realize who I was: a medical doctor dedicated to helping others. I had proven to myself that I could succeed in research, carving my own way forward with hard work. The time was right, and now I was ready for another challenge.

Immigration was difficult during the Reagan years, which presented new difficulties after I made my decision to stay in America. I had several job interviews, one of which was at the Mayo Clinic in Rochester, Minnesota. Dr. Malik told me to dress like a professional for the interview. I came from Sweden, where then, clothing or appearance had little impact; there, a person's words were what mattered most. The next day, my mentor and his wife bought me a gray professional suit to wear for my interview. I vividly remember the lake on the grounds at the Mayo Clinic, teeming with loud honking Canada geese. At that moment, I felt very happy because it reminded me of the Swedish countryside.

Full of confidence in an "unknown," I apparently presented myself well. Three days later, I was invited for a final interview. Sitting in front of a panel of five people who would decide my future, they told me that I could start work the following month. The brightness of that moment will remain with me for the rest of my life. My time was coming, or so I thought. Then came a question about a work visa, which I did not have at the time. Sadly, the Mayo Clinic was not willing to sponsor me for a visa. There are times in your life that you want to forget. This was one of those times.

Back in Memphis, I began looking for positions that would sponsor my application for a work visa. A few months later, I was accepted for a position at the Veteran Affairs Hospital in Gainesville, Florida. The United States government became my sponsor as I returned to my career as a medical doctor in America.

# CHAPTER TWENTY-NINE

AFTER MY FIVE years of research in Memphis, I moved on to a medical fellowship in Gainesville, Florida. At last, my life became a little easier. Working as a medical doctor in training paid more than research. For the first time since leaving Sweden, I was able to live above the poverty level, but not much. Fortunately, my expectations were low by this time. Research still called me, though. In my uncommitted time outside my assigned responsibilities, I found an opportunity for clinical research with a nephrology group in Gainesville. There was no extra pay. My compensation was that I would be conducting research on patients with hypertension and not rats.

It was at this time that I was granted a permanent United States residency, in other words, I received my "green card." It was unexpected, after so long. I had applied so many times and written so many letters. Maybe they just got tired of playing with me. This meant that I could travel abroad and see my family. My existence was no longer at the whim of my employers,

and this opened up new possibilities in so many ways. I could begin to plan for my future as well as my medical practice.

One more huge wall was still ahead of me. I would need to take the examinations in equivalent medical knowledge and education for foreign medical graduates and pass an English language proficiency test. I needed to repeat some of my post-graduate training and my position at the VA completed that requirement. After I passed the Florida medical license examination board and completed my training, I could then practice in Florida or any other U.S. Government facility in the world. I applied for positions at several government hospitals, hoping that my current employment in the system would help me. After the interviews and explorations, none of them seemed to be what I was looking for in either a living environment or professional advancement. The end of my fellowship was approaching and the future was unsure. Then, miraculously, a new path opened.

My chief in Gainesville told me to call about a position at a VA hospital in nearby St. Petersburg, Florida. I was invited for an informal interview and drove for about three hours, coming to the Gulf of Mexico, then to a hospital on the bay. I saw a large new five-floor modern hospital building with older Mediterranean-style smaller buildings about the grounds. I love greenery and water, and there was a large forested area on one side and the bay on the other. My hopes began to rise. A new chapter in my life was about to begin.

# CHAPTER THIRTY

THE FATES WERE with me. I was able to transfer my credentials from Gainesville, and I was offered a full-time position. I accepted immediately and so began my new life as an internal medicine doctor in America.

The VA hospital in St. Petersburg is a five-hundred bed inpatient hospital, where we served veterans of all wars: WWI, WWII, Korean, Vietnam and Gulf. There was a separate psychiatric unit, a nursing home and a domiciliary. I felt comfortable in the government setting, where I had spent most of my previous professional life. This would be my contribution to humanity.

I began this new chapter of my life still facing so many unknowns. One day I was in the elevator and a female colleague asked about my citizenship. She was a work friend and she explained that her husband was Canadian, and even though she was an American, they were having difficulty with his United States citizenship application and paperwork. She said it would take at least five years to finally get through the process. She

went on to say that I was at risk with my position without United States citizenship. Having only my green card, my full-time position would never become permanent; it could continue indefinitely, with no guarantees and few employment rights. I understood her friendly advice, and I began the process of gaining United States citizenship a few days later.

I was in my element in the Veterans Hospital. Soon after I started, I began to work in nephrology, and with the help of two qualified nurses, we successfully opened a dialysis unit. When the older nephrologist left, I assumed the position of the acting service chief. Then, the citizenship problem surfaced. The hospital reassigned me to another position, replacing my previous position with a foreign nephrologist with United States citizenship. How ironic that he was from Geneva, Switzerland!

When a door is closed sometimes another is opened, and I found that I loved the fast-paced action of attending critically ill patients in my new position. I was assigned the evening shift, starting at four in the afternoon and finishing after midnight. I had more time during the day to be at home and have a second job at the medical practice of my friend from Trinidad, who also worked in the evening at the VA hospital. I found my niche on the evening shift. While I was on duty, I saw all of the newly admitted patients. These were generally the sickest, some had undergone emergency treatment during the day and were finally admitted to the floor for me to continue treatment and monitor their progress. Others were admitted or transferred to the Intensive Care Units, where I began their care and coordinated

with other specialists. There were patients who had transferred from other hospitals who needed evaluations before their treatments could be continued. And of course, I saw other doctors' patients after they went home for the evening. In the beginning I was the only one; the Medical Officer of the Day, MOD, and I was responsible for a considerable number of patients on all five floors of the hospital.

After two years, a second MOD was added, but the number of patients continued to increase until they finally added a third. Treating very sick patients was challenging work, but it was very rewarding. I received many VA awards, and positive evaluations from patients, staff and outside reviewers. After about five years, I received my United States citizenship, and the hospital quickly converted my status to permanent. I was on my way to tenure—they had better not try to push me around anymore!

I recall patients in cardiac arrest, and our intervention team would respond to a "Code Blue." I remember kneeling on the stretcher above a patient giving cardiopulmonary resuscitation as the team rolled the bed down the hall, rushing us both to intensive care. Then, the feeling of success if we saved a life.

One day I received a copy of a letter addressed to the Hospital Chief of Medical Staff. It was a long letter of several pages signed by twenty-seven nurses who worked with me almost all of my years as MOD. They expressed their appreciation of my work as a medical doctor and said I was a stabilizing force in the hospital. I cried with happiness—an acknowledgment of my professional work. I have to admit their recognition and admiration of me as a doctor was intoxicating.

In the mid-90s, I started a different second job. I picked up weekend shifts at a private hospital. I had two jobs, but they weren't so consuming that work dominated my life. I learned that Americans often ask, as a greeting, "Are you working hard?" Your answer is, "Oh yes, very hard," and life goes on. I finally became assured of myself as a female, hard-working American professional enjoying the fast pace of caring for critical patients.

# CHAPTER THIRTY-ONE

O NE DAY WHILE I was standing at the hospital medical library's copy machine, my gaze met the blue eyes of a tall man with dark, curly hair. When I met him, I felt a jolt, and it amazed me how strong was the physical impression he left. I was so excited. I gazed into his blue eyes, almost with a fear to openly admit how I felt. At the same time, I could feel the tenderness hidden inside of him, and it was overwhelming for me. I wanted to touch it, to feel it, I felt lost in my desire. Then I would remind myself that my work was my priority. I found out that his name was William and that he was divorced. We passed each other several times in the hallways of the hospital where we both worked, with the attraction growing more each time. Finally, we decided to see each other outside work. We had dinners and spent many evenings in our homes, talking and getting to know each other. Our time together led us to a deeper understanding of our different backgrounds.

After work, William and some of our friends went to the gym where I had been a member for many years. He and another

guy would join the mostly women's aerobics class I was in, always in the back, enjoying the scenery—a couple of scamps. We were all part of a doctors' singles group, and I was the only female. Even though William and I were seeing each other, we all had incredible fun with the singles scene. Our group became close friends. Our bachelor's club, as we called it, usually ended up eating lunch together in the hospital cafeteria planning our evenings.

This was the beginning of a new leap in my life. I would ask myself if it was really happening. We were developing such strong feelings toward one another. Was it reality or a dream; one of many? Initially, I was afraid of revealing myself, fearful that what I said or did would leave me vulnerable or defenseless. I thought, at the same time, I found a new leap, and I learned so much about myself.

In the beginning, I found we had similarities in our ways of approaching different goals, our way of thinking, and in our way of achieving different goals. Finally, I did not need to change myself. I was me, and it felt so good. The path to what I was looking for was long, but this time I found it. It took a while to find my peace, to listen to my inner self.

I was pulled toward a new path of exploration, desire, and love. Besides a physical and emotional attraction, this new relationship was developing into deep feelings of understanding, acceptance, change, and, more importantly, equality. Finally, I had met a person who related back to me emotionally and physically in a wonderful way. These feelings changed my life. I

reached a new level of personal security, another level of contentment.

The CEO of the VA hospital where we worked had powerful political connections. His dream was to make our medical center the flagship of the VA system, and he recruited many top people in all fields toward achieving this goal. William and I and several of our group were among those who had come to be a part of the dream, although, when we first came, we weren't aware of the plan. We were enjoying the spirit of Camelot for professional growth and achievement. In my new country, this was my first real position after research and clinical fellowships.

Soon, William and Mama met, establishing an instant rapport that superseded language. Mama called him by his last name, Webster (it sounded so nice) and he was Webster from then on. He told my Mama, with me translating, that his family lived in North Carolina. His father was a pharmacist, so it was natural that he assumed his father's pharmacy and developed a highly successful practice. After fifteen years he felt he had met his parents' ambitions, and he began his own journey, a leap you may call it, to fulfill his own dreams. His parents were emotionally supportive and understood the need to find oneself. William was one of seven people chosen from all over North America and accepted into an unique doctoral program, with a scholarship, at the University of Florida in Gainesville. He began a new life and profession.

Webster was leaping into the unknown just as I had. After several years, he completed his doctor's degree and prepared for

another leap, to the VA hospital in St Petersburg. However, his wife was not prepared to leap with him. She had found her dream where she was.

Coincidentally, a few months after William left Gainesville for St. Petersburg, I arrived from Memphis to Gainesville and joined the same university. I didn't know karma was on my side, guiding our paths to the same destination. After a few years I moved to St. Petersburg and joined the staff at the same VA hospital. The universe had coordinated time and place, the rest was up to us.

Webster's father had been in the Air Force when he was born, and they lived on a military base in Georgia until the end of the WWII. We both began our lives in wartime where goods were scarce and the future was uncertain. We both were the oldest child and had younger siblings. We were just born in different parts of the world. It is reassuring that fate or circumstance can bring together people born continents apart.

That is how we met. A couple years later we decided to intertwine our lives-we became husband and wife. With parents, brothers and sisters, children, nieces and nephews, the bachelors club and other friends at a historic, beautiful beach hotel, my brother walked me down the aisle, while Mama cried from happiness. My nieces, Sandra and Linda, were my ring and flower girls, and Webster's daughters were my bridesmaids. Our coworkers at the hospital told us it was the event of the season. After the ceremony, with a cover band playing Foreigner, along with our families and guests, we danced the night away. I was

loved; I was precious to someone, and someone was there for me to love back.

Life together started in St. Petersburg in February 1989. I had applied for my United States citizenship before we were married, and after a few years, Webster and I went to the old theater building in downtown Tampa where I was sworn in as a naturalized citizen and given a blue passport. Later on, this blue passport facilitated our travel all over the world.

As time passed, I realized some powerful force drove Webster. He had many responsibilities—his work with consulting in the medical and surgical intensive care units (ICUs), his fellows, residents and staff, and research—that many times held him late into the night. He published many scientific papers while at the VA hospital and held appointments at several universities.

Webster and I enjoy and need music in our life. He played French horn in his school orchestra for many years, and he says that he was fairly good and could have received music scholarships if he wanted. There is always music playing in the background at our home. Our musical interests have taken us far, as far as Carnegie Hall in New York, where we sang for a VA homeless benefit program. We were in the chorus behind Shirley Jones and Kathleen Battle. We enjoyed a little bit of Manhattan over those cold, windy and snowy days. Love can take you places that you never expected to go.

My husband is constantly planning for new challenges. He says that my love is what gives him the courage for his own new leaps into the unknown. The hospital had created a special

position for him; then, after some years, he felt the need to go on, to find another leap. Webster left the hospital and took a position in the pharmaceutical industry. After a few years, hc was a regional director of Global Medical Affairs in a large pharmaceutical company, and the reputation he had acquired at the hospital was paying off. He traveled from one end of the country to the other as a pharmaceutical company doctor to speak peer-to-peer. The years of research gave him a benefit. He says that my love gives him a special advantage; he does seem happy to be home when he returns.

Balance between our two lives is what makes us strong. Webster's passion is diving and spearfishing. He dives with very accomplished and adventurous buddies; he is happy when he is wet. All around us are couples in conflict as they try to reach a balance with their personal time and shared time. Somehow, we have an understanding that happiness for one is happiness for the other; a victory for one is a victory for the other. He schedules his time with my work and family time, and I schedule my work and family time with his. He has traveled to remote parts of the world on the quest for underwater adventure. He doesn't talk about his adventures all that much, but his website has videos and thousands follow him. People ask if I dive too, but I say no, but I am happy when he does. This makes our times together more intense and give us the balance we need.

When we travel, and the weather is not good, especially on our winter trips to Sweden, we spend some time in coffee shops playing chess. Webster, with love, has taught me the fatal moves

to avoid; so now, I sometimes even win. We feel comfortable, and with him, I feel loved, safe and content.

The best is that I am still able to feel the young girl inside me, to dream her dreams, to reach them, at least the majority. Today I am me; today I can see the picture of the young girl in my eyes and the heart. Holding onto each other, Webster and I feel the power of understanding, acceptance and love.

We have shared our life together for almost thirty years, about half of our adult lives. Those years together are for another book. Our life has many, many stolen hours of shared intimacy, and I've learned to trust, and I know that what they say is true: the earth does move.

And now as we stand side by side, we take our moment and then leap together, into the next unknown.

# CHAPTER THIRTY-TWO

IT WAS AN idea emanating from my soul, from a deep part of me, an idea that found the time for its expression. Early in my marriage to Webster, we went on a trip to Montreal for him to present his research and me with a secret desire to live some of my European heritage.

At that point, I wasn't even sure whether I missed it or whether it was an idealization of something within me, not palpable, from my past. I was full of anticipation to feel the atmosphere of what I thought I had lost, "the European flair." I would speak French there and be very pleased with myself. Then, I asked myself, would I feel pain for the time I had lost? Would I be sad or indifferent toward events beyond my control? Would I feel some relief? I felt my curiosity growing as we approached Montreal.

I asked myself whether I wanted to go home, and in that case, where was my "home" anyway? Was it in Belgrade, or Sweden or the United States? My heart pointed toward the latter. I had no answers at the time. It was a longing or yearning,

an urgency to find out if this leap would evoke feelings or emotions in my soul. As I look back, I did not fully understand the reasons for the questions in my heart.

On the flight I thought about whether I had been in denial, tucking away these thoughts as a protective shield for all these years. Did I want to protect myself, telling my searching soul I had done the right thing by leaving everything behind me? Did I want to return to my spiritual roots? Did I learn to fly without boundaries...did I leave or did I go?

For years, I was eager and restless to find a place on Earth to call home. At this time of my life, I was not sure where my home was, although I did not feel a loss. I wanted to believe in the magic of the world. It was a year of El Niño, the climate condition named some two hundred years ago for the Christ child, the global weather pattern coming from exceptional warming in the deep Pacific waters. I felt as if there was an emotional and spiritual climax around the globe. It was as if everybody, including me, was affected in one way or the other, and it was difficult to explain.

A mysterious veil separated my conscious mind from my subconscious. I felt it in the air, in the rain, in the wind and in the clouds. Maybe it was time to free my thoughts. I believe in the forces of intuition and spiritual guidance, and these forces have guided me throughout my life. So, while I often felt guilty in the past, I still had no answers.

Sometimes I compose poetry in my head. It clears my mind, and it gives me emotional relief. It helps with finding home. Maybe my inner home is a part of accepting who I am and what

purpose my poetry plays in understanding the globe and universe. We are all connected somehow with sometimes invisible, sometimes tangible, lines and energy. We took a direct flight to Montreal with those thoughts tumbling about in my mind.

We landed in Montreal and searched for our bags, but they didn't come around on the belt. Anxiety and tension began to build. We checked in very early in Tampa—I was too excited to wait at home. We didn't know it, but our checked luggage was put on an earlier flight. We went to the counter to ask about our bags, and there they were, on a cart. We were now ready to roll them away, out of the airport to find a taxi to the hotel. As soon as we were on the streets, we noticed the signs were in French with English in smaller letters. I thought, how nice that I spoke French. The adventure was beginning. My questions and inner conversations flew away.

It was unusually hot in early September when we arrived in Montreal. We had packed for cooler Canadian weather. We found our hotel, the magnificent Queen Elizabeth, which was above the Metro and central train station. We could feel rumblings when the large trains passed underneath. We were eager to see all we could and bought multi-day metro passes for exploring. The Montreal Metro is very modern and made a singing sound as it rapidly left the station. After looking at the map, Webster and I boarded a train from the station under our hotel for the convention center where he registered for the research conference. Then we rode the metro to the next station. We took in a bit of the area and then boarded another train for the

next stop, seeing quite a bit of the city as we went from stop to stop. After returning, Webster and I went to a small neighborhood pub near the hotel and ate dinner. Afterwards, we went to our room holding each other tightly, feeling we had reached our nirvana.

The next day, my husband presented his work at the Palais des Congrès convention center. While Webster was at the conference, I went to the tri-level underground shopping mall filled with beautiful stores and restaurants. This underground city stretched for many blocks in all directions beneath the city and connected to pedestrian tunnels and the city's subway system. I bought a Chanel purse and a black leather skirt—I was happy to find quality leather goods. From there, I took the Metro to the green areas of the Parc-du-Mont Royal and the Jardin Botanique Park.

I remember Montreal as a bustling, multi-ethnic city, full of wonderful cobblestone-streets in the Old Town, *Vieux Montreal.* This area beside the river, the site of the original settlements that grew into the city, now was restored to its former beauty. One day, we walked from our hotel to see the Basilique Notre-Dam-de Montreal, with its seven thousand pipe organ. We, along with the many visitors, gazed up at the thousands of stars spread across the vaulted blue ceiling, made of twenty-four-carat gold. I lit several candles and prayed for my family before we left.

There were jugglers, streets musicians and magicians performing in public squares. We walked through the parks along the riverfront of the Saint Lawrence Seaway, the great

waterway where ships travel from the Atlantic to the Great Lakes. The region was originally settled by France, but later came under British rule. The majority of the residents still speak French as their primary language. After our excursions, we ate dinner in a very nicely appointed restaurant in the hotel; after a French dessert, the room in our hotel beckoned.

The next day, we took the metro from our hotel to the convention center to see the exhibits for a short time. We looked toward the city and saw Montreal's Chinatown with the distinctive sweeping roofs with upturned corners. It seems impossible now, but at the time, I had never seen a Chinatown. I had come to relive my European life, but now, something entirely new was in front of me. We walked the streets, filled with both tourists and Asian citizens of Montreal, stopped and looked at the restaurant menus, browsed the Chinese shops and businesses as we passed through gates with the same sweeping roof lines, separating the sections of Chinatown. We explored for some time, eventually coming to a "regular" street. We headed uphill and soon turned left onto René-Lévesque Blvd toward our hotel. As we walked back, I was collecting scenes of this new discovery in my mind.

This was the week of the *Festival International des films du Monde*, held in late August-early September. This well-known international event had over four hundred worldwide entries. Though we didn't find time to see these films, we saw advertisements everywhere and passed several movie houses where films were showing. All I remember was one highly rated film with something about a rooster in the title. Later that year,

back home, we saw our local movie theaters advertising films that won awards at Montreal's international festival—maybe there will be a next time for us in Montreal.

One evening, we went to an unforgettable performance of modern ballet, set to the music of Heitor Villa-Lobos. We were both mesmerized by that evening of enchanting music and dance, unlike any we had seen before or have seen since. Webster was familiar with the work of Villa-Lobos, with sounds from indigenous people in the Brazilian jungles. Somewhere, he had a vinyl LP in his old collection. He was familiar with ballet and wasn't a fan, but that evening he became an enthusiast of modern dance set to unique composers. Sadly, we have never been able to find a comparable performance—maybe it was our excitement from being together in a new experience in a new city.

We visited the Montreal Olympic Games Park, which was built in 1976 on an island in the St Lawrence River. The geodesic dome was the prominent structure we first saw as we exited the metro station after passing under the river. We saw the world's tallest inclined tower arching over the stadium in a graceful sweep. Cable cars took us up the side of the tower to its large viewing deck overlooking the city and the waters around the island.

In the evening, a medical company invited us to dinner. We only had the name of the restaurant and had taken a taxi. When we arrived at the location, we realized it was on the same island as the Olympic Village. People at our table were talking about possible difficulties getting home because protesters from local

Indian tribes were blocking the roads. Since we had visited the Olympic village before by Metro, we let our fellow diners know a subway station was nearby. It was decided by all to take the Metro back to the city, which turned out to be easy, and we arrived safely back, directly under our hotel.

The next day, we strolled through the Rue-St. Denis, which was filled with many sidewalk cafes, restaurants, bars and galleries. We were in the middle of Montreal, walking on streets, breathing in the European atmosphere and hearing French being spoken everywhere. I felt enriched, my soul was elevated, and I was asking myself whether I had found what I was looking for. I could admit that I wasn't sure; I felt that a part of me belonged to this European heritage. It felt good, and it evoked warm feelings inside and gave me the strength to further explore my inner self. Did I find my home here? I didn't know. I learned that perhaps I did not really want an answer at that time. I was still searching for a connection between my inner world and my outside reality.

Many years later, I would find it.

# CHAPTER THIRTY-THREE

A JOURNEY INTO the realm of magnificent nature can bring significant rewards to a searching soul or relief from a stressful life. With those thoughts in mind, and the excitement of the new adventure, my husband and I went on a trip to Toronto; he, attending a scientific conference, and I, just a partner in a new adventure. It was September 1998, and I was ready to enrich my life with a new experience.

It was a warm day with a cloudless blue sky when we boarded a flight to Toronto. There was a direct flight from St. Petersburg and when we arrived, after about three hours, we were met with Florida weather in the Canadian summer.

Prior to that trip, I had talked with a friend in Florida and told her that we would be traveling to Toronto. She asked, "Why that city? Isn't it the same as any other U.S. city?" I said that it was a new adventure and it depended on your expectations. Mine were to have a new experience, regardless if it was in the U.S. or Canada. Webster had never been to Toronto either.

In the taxi, the experience of a new country filled me with excitement. It felt good to have a change of scenery. I was lucky to have a free week from work at the same time as my husband was scheduled to attend the conference.

I spent the next two days browsing the nearby streets of Toronto, looking into the windows of many shops and having a wonderful, strong feeling of adventure. The Canadian exchange rate was very good at that time so I bought cosmetics and other items I use. The language was the same as in Florida. Although I had expected to hear some French, I didn't. Two days later, we were on an excursion bus passing cedar and pine forested land-scapes, small cascading streams, and picturesque houses sur-rounded by the beautiful, natural greenery. We went to nearby Niagara Falls.

We heard the thundering from miles away. As we left the bus, the enormity and spectacular sights and sounds of Niagara Falls took our breath away. We had to tell ourselves to breathe as we walked toward what looked like a giant wall of water over 187 feet (57 meters) high, dividing Canada and the United States. There are three waterfalls, where the river is split into twin channels by a small strip of land, Goat Island. On one side is the Canadian Horseshoe Falls, and on the other side, the smaller American Falls, along with the narrow Bridal Veil Falls.

With the other tourists, we boarded a tour boat, the Maid of the Mist, which would bring us to the edge of the massive cascading waters towering above us. We were awed by the over-whelming, wild, roaring Niagara Falls. We experienced power-ful feelings of our own smallness.

It was sunny and we saw beautiful rainbows in the spray. Bewitched by the wonders of nature and listening to the enormous rumbling of water, we felt lost in this magnificent, mist-covered landscape. We felt as one with the symphony of its magical nature. Our boat felt insignificant compared to the greatness of this natural wonder. We spotted hawks carrying prey in their beaks flying over the mist toward the forest. We could not slow the passage of time, and surrounded by the powerful energy of nature, we both felt our spirits enlightened and elevated.

Our boat maneuvered close to the foot of the falls, and raincoats were passed out to protect us from the torrent of spray produced by falling waters. We stood on the deck of the boat, mesmerized by the thundering waters of the falls as they roared over a semicircular cliff and plunged into the cauldron below. The mist surrounded us as we watched transfixed by the power. It was an awe-inspiring sight, just unforgettable. Soon afterwards, we docked and left the boat continuing our adventure on the White Water Walkway at the bottom of the gorge, leading us away from the falls. We looked at whirlpools and rapids, which looked treacherous in the waters that flowed away into the newly formed river; creating such power on its way to Lake Ontario. We both were happily covered with the mist of Niagara Falls as we walked along.

We had experienced a new adventure together that would enrich our lives and memories forever.

*O wonderful nature,*
*bring me scented breezes,*
*let me hear the thunder of the water,*
*bring me petals of colorful flowers,*
*let me feel your almighty powers,*
*bring me sense of freedom,*
*let me hear sounds of your kingdom.*

*I opened my heart to your power,*
*I brought you my precious flower,*
*I embraced you with ecstasy,*
*hugging you breathlessly.*

*Life hidden in the trees,*
*life blossoming in water lilies,*
*life flying like chirping birds,*
*life bringing me wisdom words.*

*I hear the song in my soul,*
*I see the colors of the rainbow*
*I stretched my arms toward you,*
*O nature of my soul,*
*I am surrendering to you.*

Tatjana Webster, Canada
1998

# CHAPTER THIRTY-FOUR

IT WAS IN the early fall of 2005 when Webster and I made one of our many family visits to Sweden. Mirko had a surprise gift for us: a three-day cruise to the capital of Estonia. A year earlier, I had gone to the same destination with Mama, Mirko and his wife, Ann.

Mirko drove us to Stockholm, where we boarded a new cruise ship, the *Victoria I*, destination, Tallinn. My husband and I were excited about our new adventure. After unpacking in our cabin, we went to the salon on deck seven. Sitting in comfortable lounge seats, next to a large window with a panoramic view of the many islands of Stockholm's archipelago, we ordered drinks and were enchanted by the passing scenery, enjoying the start of our new adventure as the ship made its way to the Baltic Sea.

One of the islands we passed was Lidingö, where my niece, Linda, was living at the time and there we saw a familiar landmark, Carl Milles Gården, on the top of Lidingö hill, which we had visited several times by land. Looking out the window,

we had a grand view of the soaring, elevated works characteristic of Milles' sculptures, having a different perspective, from our ship's view as we made our way out the channel. In the air, above Milles Gården, we saw one of his most famous works, the small figure of a man held in the palm of a large hand, raised high on a pedestal toward the sky, *The Hand of God*.

Our cruise ship was gliding easily through the water along our route, occasionally passing close to some islands. We saw houses, gardens, boats at docks, forests that came to the edge of the water, with gray beaches covered by smooth stones. People were outside enjoying the last days of warm weather. It was like a picture, and I felt I could almost reach out and touch the images.

That evening, we were happy to find a huge appetizer buffet of Swedish delicacies, with three types of caviar, whole smoked salmon, pickled herring, cured meats, many cheeses, salads, fruits and pastries. The entrées no longer seemed interesting after we saw the appetizers. This was our dinner, and we indulged in Swedish culinary artistry as we sat by a large picture window and looked out over the sea.

Afterward, we went to a clubroom where a stage and tables enticed us to come close. We found seats fairly near the front and ordered drinks. The nightclub show was the same as I had seen the year before. It was a huge review, with Russian girls singing and dancing. It was worth a repeat. The woman who was the Mistress of Ceremonies (MC) announced each act in several languages, switching between them without taking a breath.

Then the MC announced that it was audience participation time, and I entered a dance competition where assigned partners held a ball between them, only using their foreheads (hands were not allowed). The tempo of the dance increased until the last couple that had not dropped the ball was the winner. To my big surprise, I won with my partner, an unknown passenger who was around my height. The prize was a basket with fruit, chocolate and a bottle of champagne.

After the show, for a while before going to bed, we stood on an outside deck and watched the moon reflecting on the water as we made our way across the Baltic Sea. The cruise ship ride was smooth, although Webster likes the rocking of a ship, saying it makes for the best sleep, so he was disappointed.

The next morning, arriving at the dock in Tallinn, and along with our fellow passengers, we passed through Estonian entry control and received stamps in our passports. Leaving the port area, we walked through the gates into Vanalinn, the medieval old town surrounded by thick walls. We walked over winding cobblestone streets and arrived at the Town Square. We had stepped back in time, and the old city had changed little from how it had looked in the fifteenth century. The Russians had occupied Estonia for many years, and it was evident that they had never spent a penny on modernization. They had not replaced the original cobblestones, but the buildings were in good repair and had a patina of having been undisturbed for centuries.

That year, the Tallinn early fall weather was beautiful, and people filled the town square enjoying open-air shops and

restaurants. Webster noticed the long shadows and realized that we were far north. From where we were sitting during lunch, we enjoyed the view of the medieval buildings, the Gothic Town Hall and the surrounding Square. After lunch, we went into a small, charming museum displaying old medical instruments and a few pharmaceutical curiosities.

We continued exploring the streets of Tallinn, passing Viru Street, which was packed with bars, restaurants and shops. In one souvenir shop, I bought a cobalt blue vase with gilded accents of gold leaf that now decorates our living room in Florida. We spent some time in the square, taking refreshments at an outdoor cafe and looking at the Alexander Nevsky Russian Church, with its magnificent, towering onion domes and golden crosses shining in the sunlight of our beautiful day, a remembrance from the days of the Tsars of Russia.

We then went on a bus tour of the city. We passed many tall apartment buildings that are typical in Europe. They were nicely kept and the area looked modern. Our guide announced that this was where the Estonian people lived. We passed several more nice apartment buildings, and then the bus slowed as it passed by a run-down area of apartments. The guide made a point of saying that this was where the Russians lived. We could feel the resentment in the air due to the long occupation of Estonia by the Soviet Union.

Next, our bus stopped at the Russalka Memorial, built in honor of soldiers who drowned in the early 19th century when the ship *Russalka* (Water Nymph) sunk en route to Finland. A sculpture of a bronze angel stands on tiptoe atop a block of

rough granite, holding an Orthodox Cross pointing in the
direction of the sunken ship. We were informed that just
married or engaged couples come to this statue to have their
pictures taken; maybe it is the beauty of the sculpture that
inspires hope for the future. There were older women on the
sidewalk nearby selling beautiful handmade lace, and I bought a
couple of doilies.

Our bus tour continued to show us an interesting cross-
section of Estonia. The commentary was in both Estonian and
Swedish as our guide announced the next place we would see,
the Song Festival Bowl, which featured unusual architecture.
The large, shell-like amphitheater was built in the sixties; it was
built as a symbol of Estonia's faith in the future. In 1988,
thousands of people had gathered there to show unity against
the Soviet occupation. There were hundreds of trees planted in
the surrounding forest, and each tree represented a person who
had lost his or her life for liberty and country. We stopped for a
while, enjoying the ambiance as we walked around the park
taking pictures, and then boarded the bus back to the terminal.

Returning to the terminal, we saw several huge warehouses
full of alcohol products, and we began to understand that all the
empty suitcases we had seen rolling off the ship would return
filled with tariff-exempt product. Webster found a woman
selling *matryoshka,* nested dolls. He had seen them at the
souvenir shops where the price was always high. Here, however,
it was reasonable. She took cash only and pointed to a bank
where we could change money. Webster took twenty dollars

and came back with a huge handful of Estonian money. He paid for the dolls and had quite a bit left over.

Later, we went through passport control and boarded our cruise ship returning overnight to Stockholm. Our lives had been enriched with glimpses of a little piece of medieval Europe and a country rising after the Soviet occupation. We sat with a drink at the bar as we remembered our day. Later, we went outside to the top deck and stood there holding on to each other, looking out over the shimmering moonlit sea.

# CHAPTER THIRTY-FIVE

MAMA WAS BORN in the Croatian city of Split, the Dalmatian regional capital located on the Adriatic Sea. Near the end of her life, Mama, Webster and I all traveled together from Florida to visit her birthplace. Webster arranged flight upgrades so we traveled in style. Mama figured out the business class seat buttons right away, but I had to ask for help.

We made our reservations at the classic Hotel Park near *Bacvice*, a popular beach location. From there, we walked every day to the *Riva*, a broad walkway with the harbor on one side and restaurants with canopied open air tables and shops and the Diocletian Palace on the opposite. We joined the people promenading every evening at sunset on the *Riva*. Directly in front of us, as we walked with the water on our left, we could see *Marjan Hill*.

The air was heavy with Mama's memories. At home, there was a photograph of her sitting beside the harbor, next to a docked sailing ship with the *Riva* in the background. Another cherished photograph showed Mama and Papa together on the

*Riva,* Papa in his dress military uniform and Mama in a pleated dress, with *Marjan Hill* in the background. We relived these memories, standing in the same places they had in their young lives.

*Love was in the air and in their hearts with Mama and Papa enjoying a day on the Riva with Marjan Hill in the background: Split, Dalmatia, 1939.*

Several days later, we visited *Marjan Hill,* and Mama told us about being a young girl and falling in love with Papa. They had walked along pathways hidden in the shadows of the many pine trees, they watched waves caressing gray stones glistening in the sun on the beach and listened to the symphony of a million cicadas. It really was, and still is, a lover's paradise.

Along the coast, on the other side of *Marjan Hill*, there are many restaurants and marinas filled with sailboats, their masts spreading out as far as the eye could see. The smell of smoked fish was in the air, along with the music of Dalmatia. It would be easy to fall in love there.

Mama's birthplace was on a square next to the palace built in the year 293 AD by the Roman Emperor Aurelius Diocletian. When it was completed, he abdicated his position as Emperor and retired to his new home, a massive residence on the Adriatic coast later called Diocletian's Palace, in what is now Split's central waterfront. As we explored the palace streets, we enjoyed the worn marble squares paving the open spaces and walkways. In niches, carved ornaments adorned the walls in the restored passageways and rooms as well as beautifully carved statues the emperor had brought from Italy and Egypt.

On the *Narodni Trg, the People's Square*, today surrounded by grand old stone buildings, restaurants and bars, there is a five-story apartment building. On the fifth floor, overlooking the square is where Mama was born and where she had lived until her father, Miro, bought an apartment a few miles away, in a house on a hill. As we ate dinner in a restaurant, I could picture Mama here as a little girl in the building across the square. We passed this way, through the square, every day on our way through the city. As we enjoyed the sights and the memories, I thought about how happy my brother Mirko and I were as children when we spent summers in Split. I was always hungry for ice cream. I had admired the unusual forms and sculptures, columns, and other architectural remains of this old

city. It had left a deep impression in my young mind, causing a desire later in life to possibly become an architect. It turned out that my fate was altogether different.

One day, as we passed, we decided to step inside Mama's old home building and look around. While walking up the stairs to the fifth floor, Mama was telling Mirko and me a story from her childhood about going to the large terrace outside their apartment to play. For adventure, she used to go through the window onto the terrace. That memory stayed with her all her life. Mama could have used the door but that was not her way. She preferred adventure despite Noné's protests. She told us that, from the terrace, she could see Iron Gate (Porta Occidentalis), one of the ancient entrances to the Diocletian palace.

Filled with excitement, we easily climbed the five floors to her childhood home, with Mama barely holding back her tears. We stood outside the door of the apartment that had belonged to her family and knocked. No one came to the door. We stood for awhile, reliving her memories. Then we turned, walked down the stairs and continued walking through the city, exploring her past.

That summer, when we visited her old home, feelings of joy and happiness were somehow mixed with sadness. We felt, at times, that the memories of Mama's childhood were overwhelming. We did not know if it was the last time that we would all be together in Split. Sometimes we cried and sometimes laughed, denying that deep down we knew it was the end of her era.

While growing up in Belgrade, we took long train rides from Belgrade to Split for summer vacations. We swam in a cove with a beach, Bacvice, named for its barrel shape. On this return visit to Mama's city, we went with her every day to Bacvice and swam and floated on the blue waters of her beloved Adriatic Sea. Pictures of her are still vivid in my mind. She was so happy jumping from the steps into the sea. Then she would hold her nose and swim under water, coming up with great happiness on her face. She was 91 years old and in paradise; and so were all of us. At a small seaside pavilion, we sat under umbrellas and ordered lemonade and ice cream. After we were refreshed, Mama was the first to jump back into the water again. Mama's cousin, Arsen, came by to talk a few times, and he would bring watermelon and cherries for us. Those days, so full of contentment and happiness, will stay with me for the rest of my life.

As we looked from of our hotel windows, we saw large ships on the horizon ferrying people to the many Dalmatian islands. One day after breakfast, we walked from the hotel to the waterfront, bought tickets and boarded the ferry from Split to Hvar Island, where we disembarked. Hvar is a beautiful Dalmatian island and a popular destination for vacationing celebrities: Beyoncé, Tom Cruise and Prince Harry, just to name a few. The harbor is filled with yachts hailing from all over the world.

The stones of the island are remnants of the history of Hvar from the fourth century BC to the present. Traces of ancient conquerors are still visible today. We left the ferry and walked

onto the quay leading to the town square. We walked along breathing in the fresh lavender and pine-scented air while looking at the stony beaches and the clear dark blue waters of the Adriatic Sea. Cactuses with red blooming flowers were sprouting among the large rocks along the water, and the towering spiked blooms of agave were everywhere. We saw people along the shore sunning themselves on the rocks. Some had made the swim from the yachts, anchored nearby. Looking at the shops, restaurants, churches and hotels as we passed by, we began to feel the enchantment of Hvar.

Mama visited the island during summers with her granddaughters, Sandra and Linda, when they were in their teens and was reminiscing about their times and how long ago it seemed. As we passed a restaurant, Mama told me about sitting there with Linda talking about life and love. Birds were chirping in the trees along with the sound from a million cicadas, playing an unusual symphony as I looked up through the tall trees at the blue sky, wishing that our trip would never end.

Walking further on the island, we could see hills and stone houses built with small windows to keep out heat and the strong north winter wind, called "*bura.*" High above us, we saw craggy limestone ridges sprinkled with olive trees, fruit trees, grapevines and tall pines; lavender and rosemary perfumed the air we breathed. That day, we sat outside a small restaurant on the town square and had coffee and pastries. People walked by and we simply enjoyed life as we took in the timelessness of our surroundings. Dominating the city above us was a large fortification with thick walls to repel ancient invaders. You

couldn't help wondering how many millions of people had walked the same worn stones under our feet.

We were there on Hvar: Mama, Mirko, his wife Ann, Webster and me. I don't recall whether I was ever happier in my entire life. Our return was overland, across the island by bus from Hvar Town through the mountains to *Starigrad,* where we connected with the return ferry. The land we crossed on winding roads over the breadth of the island was terraced with the remnants of stone walls, and we couldn't tell if they were for ancient vineyards or olive groves. From the top of the high hills, we could see coves with secluded beaches and sometimes boats anchored along the shore. From a distance we could see people enjoying the sun and water; it was a sailor's paradise. There was green grass in patches among the gray Balkan rock, and the vistas overlooking the sea were deep blue with heavily forested shorelines.

After some time traveling overland through steep hills with hairpin curves where we could see traffic directly above and below us, we arrived at a modern shopping area outside Starigrad and had coffee while we waited for the ferry to arrive at the dock directly across the road. We boarded the ferry and took seats outside on the second deck where we could see more of the small islands that we passed on our way back to Split.

A great gray-white bird swooped down and landed on the boat deck master's pole as we were leaving the beautiful island of Hvar. It reminded me of a dove. It called out the familiar sounds I sometimes heard in Florida. I looked up and saw it, and it looked like it was staring at us with an intense gaze. It felt like

this bird could almost speak to us. Mama looked up and saw it, not saying anything. We traveled by boat for about two hours, and the bird, occasionally calling, did not move during the entire trip back to Split. Suddenly, approaching the town of Split, the bird called out louder, still not moving from the mast as though it were telling us something. At that time, I didn't know what Mama was thinking, nor did I ask her about it. I had a strong premonition that this would be our last trip together and that we were rapidly approaching a foreboding event. I felt scared while I tried as hard as I could to ignore those feelings. After all, we had an unforgettable time together on Hvar. I still believe the bird, which reminded me of the doves my Papa had loved so much during his life, was a sign from the universe that my Mama's life on Earth would soon end, and that she would not be alone. I believe the bird was a sign of compassionate guidance given to us, a message directly to us. I would never know whether it was a coincidence or just an unusual event.

Could it be that changes in the dimensions, the challenges of time and place working in synchrony, may or may not lead to our understanding of the many problems and events in life? I realized a long time ago that each sign and evoked feeling has a reason for its existence. It may help us on the long pathway of future events we are not aware of yet.

# CHAPTER THIRTY-SIX

SOMETIME AFTER OUR return to the United States, Mama and I sat down at a local seafood restaurant not far from where we lived. Nailed to the walls were dollar bills, the names and dates of visitors written on them. It was a casual fall day. The oppressive heat and humidity of summer were gone and had left behind a balmy, tropical season. The waitress came with her notepad in hand. Mama spoke in English, "I would like some oysters with lemon slices and French fries."

I said, "I am having chowder and a salad."

The waitress left with our order. Then I said that we should call my brother in Linköping, which we usually did at this time because of the six-hour difference. We never made the call.

Suddenly, Mama's gaze shifted to the right, and she was unable to speak or move. I screamed, "Call the ambulance," and immediately started crying. I realized that she was having a stroke. People in the restaurant tried to help as best as they could.

The sound of the ambulance siren cut me to the quick. Everything passed in a blur, and soon they were rushing Mama to the emergency room. I don't recall how I found my car and collected our belongings. I didn't stop my Volvo at red lights as I followed the ambulance tightly. The siren wail caused a growing terror that pushed out everything that was deep inside me. At that moment I wasn't a medical doctor; I was just a daughter who had seen her mother suffering. Somewhere deep inside me, my heart was hoping for the miracle that in reality would not happen.

After tests and a brain CT scan, Mama was moved to intensive care. Webster and I felt totally powerless, a feeling mostly foreign to us.

The doctors gently told us, "Nothing more can be done. It looks like the stroke involved both sides of her brain."

Many of my colleagues called to give me moral support and offer their help. Webster was with me most of the time, both of us feeling totally empty and heartbroken. Early one morning, at about 3:00 AM, when Mama was still in ICU, a good friend and respected cardiologist (who was once my service chief) came to give me moral support and to pray with me. At that time I was not able to think clearly and was overwhelmed by emotional pain, but I will never forget his kind words, a prayer that he offered at Mama's bed. People like him are rare and are a treasure in anyone's life.

He said to me, "Tanya, you did everything you could for your Mama. She had a long life and a happy one because of you, but you must go forward. Life goes on."

I replied, "I cannot because it is so painful." Again, Mama's words came back to me: "Tanya, turn the page and go forward."

After three days in the hospital, praying for a miracle, we made a decision to transfer Mama to hospice so that she could complete her final days of life. We had seen this kind of thing so many times with patients. We had always prayed we would never have to make the same decision in our own lives. We spoke to the neurologist one more time, and the answer was the same, even grimmer. The ambulance drove Mama and me from the hospital to the hospice unit in downtown St. Petersburg with Webster driving behind us. I couldn't stop crying while holding Mama's hands, which were becoming colder and colder.

One of the emergency medical technicians noticed my despair. She was writing something while we drove. She said to me, "You and your Mother must be very, very close. Please take this note and read it when you can; it may help." I wasn't able to read it at that time because my eyes filled with tears that blurred my vision. Later on, in hospice, I read the prayer that she had written on that small piece of paper and the kind, warm words she wrote to Mama and me. I had forgotten to ask her name. However, I will always remember her kindness during those moments of despair in the ambulance.

Emotions washed over me in a torrent during the next days with Mama in hospice. Emptiness consumed my life. I knew her spirit was slipping away into that unknown land of no recognition, that dreamless state when awareness disappears into the darkness. Her body maintained her earthly presence, but her breaths were weaker and slower from hour to hour.

I sat beside her and I kissed her cheek with each breath. We called Mirko and put the phone close to Mama's ear. We could hear him speak. What he said, I will never know. After the call a look of peace came over Mama, and it was clear that she had begun the journey of transition. She was leaving us.

Webster and I took turns at her bedside, I walked empty corridors outside her room, especially during the nights, up and down praying and crying, and then I would come back to her side and hold her hand. It was a terrible time when no words could be passed between us. No one could ease my pain when I cried. I knew what was approaching, consumed by misery. It was too soon for me to accept our sudden and final separation. The pain inside was tearing me apart. Those days in the hospital and hospice, with little sleep or food, were taking a toll on my stamina. Webster brought us plates of food from the cafeteria and then took his turn at Mama's bedside. In the morning's early hours, Webster said to me, "There is a change."

I cannot adequately explain what I saw. There was an aura of bright purple light around Mama's bed and a flickering above her body. Two small white forms, angel-like, were on top of Mama's body, and I felt a sudden peace. How they appeared, I don't know. They were there in the hours of her last presence on this Earth. They did not move; it was not a fleeting apparition. I looked at them, and I felt that the end of her life was close. I hoped that it was a hallucination, but I was completely clear in my mind. I asked Webster if he could see them, and he said he could feel something intense and unusual was happening that only I could see. Then a lilac fog rose slowly above her body. I

asked my husband if he saw this; he just looked at me in wonder and said that he saw the look of peace in my face and eyes. The lights continued, while Webster and I sat transfixed, holding onto each other for several hours as the transition completed. I knew that it was the end when I felt an increasing tightness across my chest. In the early morning a bright, pink-purple light covered the entire sky, and I knew with a profound certainty the moment when her soul had left us. I believe that a part of me left at that moment, too.

After we knew that Mama's spirit had departed, her strong heart continued to beat. We settled into a quiet routine over the course of the next day and night. Webster went home for a few hours to shower and put on clean clothes, and when he came back there was still no change. Again, we took turns at the bedside and during the night, when it was my time for rest, Webster sat at Mama's side holding her hand through the late-night hours. Eventually he said, "Tanya, it is time." We sat with Mama for her last few minutes as her heart slowed and gave a few final beats and then was quiet. The finality hit me, and I started crying out in my despair. I still could not accept the end of her life.

I had brought one of Mama's beautiful dresses from home. I left it in the room, and we went out while the staff prepared her body. We were left with our memories, and that was all we could hope for. When we returned, she was dressed and holding a lily in her hands. Her face showed a peace and eternal beauty. We knew that Mama was gone, and we will be forever thankful

for the wonderful ways that the hospice workers helped us through the last, necessary pain.

Writing about these last moments inadequately describes them. Maybe the light emanating from her body was a message to me meant to ease my emotional pain and despair. Maybe it was Mama's energy connecting with the universe and saying goodbye. I believe in prayer, and in that moment I felt numb and completely empty. I could not move for some time afterward. Later on, somehow, my rational mind recalled a *Newsweek* article. It was from a long time ago, with a poll that showed when a loved one passes, twenty percent of Americans have a revelation and thirteen percent claim to have seen or sensed the presence of an angel.

Still, the fragrance of lilacs lingers in Mama's apartment, and it gives me feelings of enormous comfort when I enter her closet. The fragrance immediately reminds me of the enormous amount of love she had for all of us, and how openly she shared that love with the world.

When someone experiences sickness, they begin contemplating their own mortality. Death is always on the horizon of life. Between the time of diagnosis and the end of a loved one's life, there is a period of despair, and the clinging to hopes and dreams are often unrealistic. This happened to me, waiting during those long days and nights in the hospital hoping that Mama would survive a major stroke. My heart was bleeding; my soul was screaming; and I felt so alone, so full of despair.

I was in constant contact with my brother in Sweden, and we shared our deep pain together. His logical approach to life

helped me temporarily handle my pain. I learned how much he missed our Mama from speaking with Ann, his wife, yet he never showed me his pain. Although younger, he took his male role seriously. Mama and Webster shared a special bond. My husband could not hold in his tears and feelings of loss at the end.

The professionals at the funeral home guided us through our farewell process, and we held a memorial service and tribute to Mama's life. I can still picture it in my mind. In the background, a screen showed an array of colors and flowing river waters with white swans floating on the surface, as we heard wonderful, slow, healing music. I remembered that from her back window in Sweden, Mama enjoyed similar scenes in nature, a romantic peacefulness with the swans and water lilies on the graceful, still waters of the Kinda Kanal. I remembered that she liked the view from another window as well, where she saw activity and life.

I sank into my seat in the pew beside Webster, allowing my mind to flow backward in time to embrace and experience the love from Mama's life. On a small table covered with palm branches, was her photo as a young, beautiful girl beside Papa, a young officer, standing in his full dress military uniform. They were on the Riva, waterfront, in Split. On another table were two albums highlighting Mama's life in Sweden and America. I hoped that people who attended would celebrate her life, would see the love in her eyes in the photographs and would feel warmth in her smile. I was crying and praying to God to help her soul fly free and allow me to feel her presence somehow.

The priest spoke of what he had learned about Mama and about her enormous zest for life, her love for her children, and her grandchildren. Her remains were surrounded by what looked to be a thousand or more pink and red carnations, the flowers Mama had loved the most. We had known our florist for 30 years, and they added golden butterflies to the arrangement as they felt Mama would like them. The palm branches reminded all of us that she came from the Adriatic Seacoast. My thoughts went back to the finality of her spirit leaving, the colors of the flowers and the color of the dawn sky when her soul entered the universe. I still wonder whether it was a coincidence or not.

The pain of separation is still strong. The strength that was left with me from her leaving is a combination of sadness, the struggle to survive every day, feelings of failure and many small achievements, all at the same time. My tears have ceased, and my heart is still full of love and tenderness for Mama. Her passion for life, expressed so many times and in so many ways, left a force inside to help me find a purpose in life. We never talked about "after events," yet we both knew that another journey would eventually start.

When he came to visit, Mirko found letters in her apartment that Mama had left, one for me and another for him. He told me that the letters were written several months before her passing. Maybe she knew that the end was near, although she hadn't spoken to either of us about it. I'm not able to read her letter to this day. I know that the pain will be unbearable. Mirko thought the letters were a goodbye to us. Once again, my brother was the stronger one.

The unread letter brings memories of Mama during her last days in hospice, laying peacefully, her face beautiful, and with every decreasing breath I would give her a kiss on both cheeks. I can see her closed eyes, and me, lost in a vanishing existence. Thomas Edison said, "I cannot believe for a moment that life in the first instance originated on this insignificant little ball we call the Earth." And I felt somehow it was the end of Mama's living on Earth and maybe the beginning of something unknown, palpable in the universe that we belong to. I feel that her soul is immortal, and it now has a new purpose. We both reached the place of an unknown. Although we are not together physically, we are connected forever in our spirits and souls.

*Make my tears a string of pearls,*
*decorate green palm branches,*
*mix them with flowers of red carnations*
*mix them with golden butterflies.*

*We are bowing our heads*
*in memory of your soul,*
*we are bowing our heads*
*feeling your passing soul*
*connecting with the Universe.*
*We are bowing our heads*
*in memory of pink and purple light*
*the morning your soul left us.*

*We are bowing our heads*
*with a new energy inside us*
*growing like a huge wave*
*flowing from the horizon.*

*I feel lost today, drifting far away,*
*yet when I gaze toward the horizon*
*I know what you would say:*
*"turn the page and go forward."*

Tatjana Webster, St. Petersburg
January 2016

# CHAPTER THIRTY-SEVEN

I'M GRATEFUL TO have a life full of memories and the many years of togetherness I shared with Mama. I recall the words of Amy Carmichael, "You can give without loving, but you cannot love without giving." My mind often wanders to memories of loving.

Our Lukić cousin, Arsen, who lives in Split, told me that Mama had a pet chicken when she was a young girl. She would put a leash on her pet and walk it around the yard behind the house where she and Noné Pina lived. Arsen and Mama called the chicken "Coka," and then later he nicknamed Mama "Coka." The last time I went to Split with her, we walked with Arsen on the hills of Marjan, and he told us how much he had loved Mama when they were children. Now, after a long life, here they were again, the two first cousins, and their closeness was still strong. Arsen had spent a large part of his life as a professional musician, and when we were at his home, he sat at his piano where he serenaded Mama with songs. I will never

forget the happiness in my Mama's eyes while she listened to his music.

On this last trip to revisit Split, while we were in Arsen's home, my cell phone started ringing, and when I answered, I heard the happy voice of my niece, Sandra, who was calling from Sweden. She asked to talk with Mama. I could see in Mama's face as she listened that it was happy news. Sandra had wanted Mama to be the first to know, even before her parents, that she was engaged to be married. Soon, we all spoke to Sandra and congratulated her and her fiancé on the happy news. As we ended the call, Mama was crying tears of happiness.

My husband and I live on the tenth floor of our building, and Mama had a condo on the eighth floor. Most days, before going to my work in the evening, I would eat lunch at her place. And, as always, I had warm feelings of peace and happiness just being there.

Every year, Mama and I would take a trip to Miami. I would attend medical conferences, and she would have a vacation. We would drive the four hours across Florida to the hotel on the Atlantic Ocean and stay for a week. I have many memories of my Mama in the hotel in Miami with a smile on her face and happiness in her eyes. She loved walking on the beach looking for shells and other treasures and the excitement of seeing so many people from different ethnic cultures and manners of dress.

One day Mama told me that she would soon be a great-grandmother. At the end of her life, the universe gave Mama a wonderful gift. One morning her younger granddaughter,

Linda, phoned with the exciting news that she was planning to have a child. Mama and I cried with happiness. This wonderful news came on the morning of the day of her stroke, which occurred that afternoon. I've often wondered if it was a coincidence or the last gift from the universe for her time with us.

Writing these pages, I'm looking at a small porcelain bell in our living room cabinet with an inscription from 1987 with the words: "The first Christmas in USA." Mama brought it as a gift on one of her first visits from Sweden, and so many memories are brought back to life when I look at it.

# CHAPTER THIRTY-EIGHT

WHEN MAMA WAS in the final stage of her life, I made a decision to take my retirement and was simultaneously overcome with grief and exhilaration. After thirty-one years in the VA hospital, I was sorry about leaving the familiarity of my evening work routine, but at the same time there was a newfound excitement accompanying the idea of being free from the confines of my job. The next morning, I called my chief and asked to be released from my duties while they began the retirement process. She said that it came as a surprise, but she respected my decision. After all, I was a senior physician, and it had only been a matter of time until I chose another direction in life.

As every woman travels through different phases of her life, her goals and ambitions are constantly changing. Therefore, one listens to her "inner voice" for direction. After Mama passed away, I started to develop balance in my life, integrating changes as necessary. And this is the beginning of my new leaps.

December 2015 and I am back in Sweden with my husband. So much has changed over the many years. People who touched my life are no longer here. We all went in different directions. Memories return as fragments of my old life, as fleeting moments caught in time. Walking the icy streets, snow is covering the park beside the road, with the barren tree branches reaching into the cold gray winter sky. We can hear the chattering of blackbirds as they flap their wings, trying to keep warm. Webster and I have been here many times over the years. We walk along the Linköping streets, reliving our trips from the past, different times and different seasons. The novelty of being in Scandinavia at Christmastime has brought us here. It is a cold, deep winter in Sweden, long hours of darkness. It is the opposite of the summer midnight sun. For a brief time during the day, life is shrouded in a gray-blue light from the northern, winter sky, and soon night engulfs the streets and descends over the city. Then, the magic happens as warm light coming from street lamps and windows pushes back the darkness, filling the world around us with a joyful glow. Somehow, even in the bitter cold, warmth seeps into me. People are moving about, going about their lives, and they seem to be enjoying themselves in the winter wonderland.

I was so happy to be back in Sweden, where I started on many journeys and made many leaps into the unknown. Webster and I sit at a cozy coffee shop where we enjoy drinking *kaffe* and playing chess. It is warm and full of people absorbed in their own worlds, and we both feel safe and happy. There, I feel that an unknown has become a known.

As we sat in the coffee shop in Linköping, others could surely see that Webster and I enjoyed a deep, intricate, intimate understanding of each other. From the beginning, our love has grown stronger year after year, giving us the strength to move forward. We say that our souls touched and became one. From the start, there was an understanding of each other's needs, wants and desires, and the love required to fulfill these for each other.

Sandra and Paul were married while we were visiting. They held the reception at their home in a high-rise building on the banks of Kinda Kanal. As we approached, the frozen snow on the ground crunched under our feet. The water was starting to ice over and was reflecting back the full moon and surrounding lights. Large rafts, some with white swans and another with a lighted Christmas tree, were floating on the surface of the canal. We stopped for moment in the cold evening air as the beauty almost took our breath, memories of childhood Christmas flooding back to me.

We still could see the swans and lighted tree over our shoulders as we went into the building and took the elevator to the sixth floor. The happy couple greeted us at the door. We removed our coats and shoes and joined family members and friends. The room was filled with a warm atmosphere of contentment and happiness. Their Chihuahua, Mimmi, was enjoying the attention as well. Sandra and Paul served a delicious international meal. My brother Mirko gave a speech wishing them a happy life, and we all enjoyed celebrating the joining of two lives. Afterward, Webster introduced them to his

family tradition of toasting special events with an old scotch whiskey, said to be the elixir the astronauts carried to the moon to celebrate their landing.

My brother invited us to his home for Christmas eve. Oh, so warm and inviting! Mirko and Ann's apartment was beautifully decorated for Christmas. The candles were lit, and a playlist of soft music was in the background. The dinner table itself was a work of art. The bright Christmas tree stood in the corner, and a star shone in the window along with the candelabra of lights that are seen in windows everywhere in Sweden around Christmas time. We felt peaceful gazing outside where the ground and trees were covered with a beautiful, fluffy white snow. The snow-covered landscape was in harmony with the warm lights and the peace we felt inside. We were surrounded by the joy of Christmas Eve in Sweden. There was a feeling of deep love and togetherness. My niece, her husband and Mimmi were with us. We added these memories of Christmas in Sweden with our family to our many other happy memories. I live in Florida, and I continue to build new memories; this keeps the past alive as new is added to old.

The next year, in December 2016, we again went to Sweden for the holidays. We noticed that Linköping had many more Christmas decorations, and the city had taken on a new festive glow. We went to our old familiar places and found a few new ones, too. Sandra and Paul had graciously allowed us the use of their apartment, as they were in Florida for the holidays. We had the new experience of shopping for groceries and supplies in Linköping, and it was a great adventure. They had stocked the

kitchen, so we were happily fed until we had time to explore the markets.

Our flight from Tampa was delayed, and our luggage hadn't arrived with us. (Lufthansa gave us T-shirts, a plastic hairbrush, toothbrush and toothpaste) It took four days for our bags to arrive, which was a long and convoluted process: Tampa to Frankfurt, Frankfurt to Stockholm, Stockholm to Oslo, and Oslo to Linköping. We were not well equipped for the weather in our Florida outfits, so we went shopping for additional clothes, and Lufthansa was nice enough to reimburse us for the cost.

The big event on our agenda was to visit the newest member of the family: Linda's daughter, Linnea. Linda and her partner in life, Erik, along with little Linnea live near the Baltic Sea in Åkersberga, a suburb northeast of Stockholm. One day, Mirko, Webster and I packed our bag for an overnight stay, and Mirko drove us from Linköping to Åkersberga. It took us about three hours to arrive. We called Linda and asked what to bring for lunch, and she said sushi. We stopped in Åkersberga and found a really good sushi restaurant. We ordered a huge takeout assortment of sushi, sashimi, wakame (seaweed salad), with all the extras. We also stopped at a bakery for some pastries. Then we drove to Linda's home in the countryside.

Two-lane roads as we drove out of town, led us to Linda's house. Mirko turned the car into the parking area in front of the dark red with white trim house. It was midday, and with the approaching winter solstice daylight was dim; the sky was overcast, and a few flakes of snow had begun to fall. The flower

beds, which must have been so beautiful in the summer, were dormant. To the right and behind the house was a dark green evergreen forest and another neighbor's house was across a field on the left. There was a garage to the right with several cars inside it. The windows of the house were cheerfully lit and full of Christmas decorations.

Erik came out to greet us with a bear hug and a huge smile. "*Välkommen,*" (welcome) he said.

We followed him to the back of the main house and climbed the steps to the deck entry. The steps were covered in fresh evergreen branches for better footing in the snow. The house was warmly welcoming and decorated for the holidays.

We removed our boots and found Linda standing near a crib with a small bundle inside. Linda gave us hugs and pointed toward the crib, and I'll never forget the moment when I saw Linnea's little face, half-closed eyes and pink mouth. She was so tiny, only three weeks old. When I took her in my arms, my eyes began to tear up. Her little body against my chest gave me a feeling of togetherness and a feeling of family continuity. This was Linnea Ann Ksemida, named after Linda's mother and grandmother.

After dinner we went out to the guesthouse, which had a main room, kitchen, two bathrooms, and two bedrooms. Behind the guest house and just few minutes' walk through the forest was a Baltic Sea bay, where their boat was moored in summer. There were horse trails through the woods where they would ride when the weather allowed.

The feeling of family was still inside me. Webster and I talked about little Linnea and our expanding family for a long time before we went to sleep. The next morning, when we awoke and looked through the window, we saw soft snow beginning to fall in earnest, dusting the nearby forest and covering the fields around the house. The peace and closeness of nature was filling our senses with happiness. In the afternoon, when baby Linnea started crying, I would walk with her in my arms and stand in front of their bright Christmas decorations. Linnea tried to open her eyes and then stopped crying. I saw that her eyes might become bright blue.

For our celebration, Erik and Linda had prepared a meal of smoked meat and Erik's signature potatoes, as they treated us to a wonderful dinner with many courses that we enjoyed along with the closeness of family. Erik, Mirko and my husband continued the Webster tradition of marking special family events with toasts of fine scotch whiskey.

After a long weekend filled with hospitality, food, drink and joy, we returned to Linköping for Christmas and the New Year. On Christmas Eve, we again celebrated with Mirko and Ann, and on New Year's Eve we went to a concert. At midnight, we heard the church bells ringing in the New Year.

In a few days, it was already time to board our flight back home. We love our fast-paced, full life in Florida. We love our peaceful and contented time in Sweden. We seem to be able to find what we need when we need it. It just took a little bit of time to reach that point in our lives.

# CHAPTER THIRTY-NINE

IT HAD BEEN more than fifty-two years since I left Belgrade. I watched raindrops sliding down the glass of the airplane window as we waited to take off from Zürich, the final connection on our long journey from the United States to the homeland that I left so long ago. A fast approaching "unknown" was growing inside me, and I didn't know what feelings would greet me at Belgrade's Tesla Airport. We were going to the capital of Serbia, one of the six republics of old Yugoslavia. After the fall of communist control, the breakup of the central government, the Balkan wars and the regional hostilities, what would I find there now?

The plane climbed into the sky, leaving Zürich behind, and about two hours later, we began the landing approach to Belgrade. Images flashed through my mind. I saw my life in Belgrade from a small girl to my leaving. I saw my parents and my brother all standing with me as I left for Sweden many years ago. I saw their tears and sadness again at my departure and their hope that I would succeed in a new world.

I looked down and I saw rays of sunshine highlighting the lush green fields and forests. The countryside was laid out with clear delineation of fields and crops. The buildings had roofs of the distinctive orange-red terracotta tile that is common in Europe. As we flew lower, we could clearly see several vineyards, their rows of grapes growing up and down along the hillsides. Tall buildings marked the city landscape with several sky-scrapers near the Danube and Sava rivers, a skyline that hadn't yet existed when I left.

A thought occurred to me: If teardrops could be combined with raindrops, a third river would join the Danube and Sava on their way to the sea. As the rivers of my childhood memories made their way towards the ocean, I watched the sunlight glowing in their mist. Water had always given Mama and me enormous peace and happiness. We felt its ebb and flow inside, keeping the events of our lives alive and moving. I suddenly wanted to feel life as I remembered it when I was a young girl. I wanted to hear the sounds, smell the fragrances and see the faces from my childhood. Yet I could not, not really, they were gone and had been for a long time.

I realized that it would be unrealistic to search for visions in the imaginary world of childhood, which had so quickly passed. This journey held great importance for me, as I believe that we all have a spirit inside each of us that will continue to grow if we nourish it. This spirit gives us purpose, helping us to search for the path leading to happiness and contentment.

It had been almost twenty hours since my husband and I left Florida as the plane touched down in Belgrade. We collected

our carry-ons, retrieved our checked bags from the belt and then cleared customs and passport control. We continued on to the duty-free shop. Here, we bought a few gifts for the people we were visiting in Belgrade, because transit time at the airport in Zürich was too short for shopping. Near the exit of the international zone, our driver held a cardboard sign with our names and we felt relieved that the arrangements had gone according to plan. We exchanged our traditional greetings. We all said, "*Dobar Dan,*" good day, and continued conversation in both the local language and English. As he drove us into the city we had the usual driver and passenger conversations about the weather, local politics and sports, and of course we gave a synopsis of where I had lived. The driver knew someone living in Florida, and he was especially interested in Sweden. Turns out, he was making plans to emigrate to Sweden soon.

As we exited the airport, with this part of our journey behind us, we could take our first deep breath--we inhaled the crisp, clean air from Belgrade's countryside. At that moment, as I stood beside the taxi, with my first new breath of air in the old country, a sudden wave of emotions swept through me. I felt a mixture of happiness, sadness, fear, excitement and power-lessness. I'm sure that my face showed all of my mixed emotions because Webster asked me, "Are you okay?" I could not answer, and I just took my seat in the taxi.

As these feelings struck me, my curiosity soon took over. All those years spent living in Sweden and then in America, I had been wondering what I would feel if I returned to where everything started. There, riding in the taxi through a city that

was both mine and not mine, I was an observer in search of lost treasures, the treasures of my youth, which were hidden in the years since my childhood. As we approached the inner city, the familiar landmarks appeared – the buildings where my Papa and Mama worked. Public buildings that were familiar still stood as they had since I left.

Arriving at our hotel, I felt like I was approaching a large and forbidden garden, and I wasn't ready to enter it yet. Then I understood why. I realized that while living in Sweden I had learned to control my reactions and my feelings, and when I found myself in difficult situations I had learned to look for a rational, inner-calming path, the type that the Scandinavians are so good at finding. Then I would discover a way that would lead me toward a resolution. For many decades, this had helped me in the struggles with memories from my past, my dreams fulfilled or not.

Without this coping mechanism, these things would have taken over all of my thoughts and feelings. I often felt that these occasional overwhelming emotions were a sign of personal weakness and that mastering them was imperative. And I was proud that I could finally say I had succeeded in my personal and professional life with the belief in myself that was passed on to me by my parents when I was young. Now, half a century later, I found myself in the middle of a storm of different emotions in an unanticipated, real experience. As I watched the rain streak down the windows of our hotel room, I knew that this journey would be both a closure of the past and an opening to the future. My apprehensions dissolved into the adventure and excitement

of the moment. I felt neither nostalgia nor a longing for things as they were, just the anticipation of leaping into a new experience.

# CHAPTER FORTY

M ANY YEARS HAD passed since I had stood in front of the apartment building where I grew up, and here I was. As I looked up at the front steps, they appeared largely unchanged yet smaller than I remembered. There were chips in some of the steps and pieces missing from the red granite railings. These steps led us to an elevator. I said to Webster, "The elevator usually didn't work." We pushed the button and it opened. We pressed the button for the fifth floor, and the elevator rose noisily before opening onto the fifth floor, leading to the apartment where I had lived for seventeen years.

In front of our apartment were steps leading down to the fourth floor, and these were the steps where I had sat so many times when our home felt too crowded. This was one of the places where I studied for many hours so long ago. In my memory, I could see all of us carrying baskets of coal or wood up from the basement in order to heat our apartment in winter. I don't know why I remembered this. Was it because the elevator didn't work back then, and we had had to walk up five floors?

*Where I often studied, sitting on the steps in front our apartment
in the 1960s during my medical school years: 2017.*

I knocked at the door of our old apartment; no one
answered. It might have been a blessing. Maybe I would not be
able to handle the pain of seeing the window near our balcony
where they told us they found Papa when he passed away. My
only consolation was that he did not suffer for long. Now,
standing at the entrance to our old apartment, it occurred to me
that he had been at home, in a familiar place.

"Why are you crying?" asked my husband as he saw the
tears in my eyes. "You should remember the happy times, too."

I replied, "I feel a mixture of sadness and happiness and a
feeling of something lost. I can't explain it."

Webster said, "When I returned to where I grew up, it was
not the same and existed mostly in my memory, hopes and

dreams. Reality was much different. I felt sadness and disappointment, too."

Then, in my mind's eye, I saw my brother and me playing hide-and-seek in the basement and our secret places in the courtyard. I remembered the families that lived in our buildings, and all the gossip and the stories about each family. As Webster and I looked across the courtyard, I pointed out each apartment and told him the story of each family that had lived there.

We took the elevator down to the second floor. I knocked at a door I remembered, and to my great surprise it opened. Lilly, a neighbor around my age stood in the doorway. I told her who I was, and after a few seconds she said she did remember me. I introduced my husband and Lilly immediately invited us into her apartment, offering us a traditional walnut liqueur for refreshment as well as some juices and cookies. We talked as though fifty-two years had not passed since the time we last saw each other. She reminded me of how my brother and I used to run on the stairs and play in the courtyard between the two buildings. She remembered that I played the piano and had gone to medical school and that I had left for Sweden.

Lilly said, "You are a little shorter than your beautiful mother."

I didn't know how to answer her. I guessed that it was her memory from the time she knew Mama after I had left. She reminded me how scared all the neighborhood children were of my Noné Pina if we misbehaved—as when we were hiding where nobody could find us, especially in the old bunker, running fast, climbing trees, and then me falling and scraping

my knees. Yes, she remembered all these things. Maybe I did not want to remember all of them.

Lilly introduced us to her son, who was a dentist and had an office in the same building. She told us about another son, a rheumatologist, and her grandchildren. Lilly talked about her father, who had been in a concentration camp during WWII, and she gave us two books that he had written about his experience. She had a full life here in Belgrade. I too was happy with the choices I'd made and that life had allowed me to make those choices.

As we were leaving, with our heads full of remembrances, Lilly told us that she knew someone in Florida, a professor whose mother worked with her ex-husband a long time ago. When I returned to the States, I found the name Lilly had given us on the Internet. She was a professor of economics and lived in Sarasota, about forty-five minutes on the interstate highway, south from my home. I called her and we have since started a friendship.

We made our way back down the elevator and outside. I took another glance at our old home before my husband and I walked away.

With all the papers and documents we needed for travel, Webster told me he needed a bag like the men in Europe used. Someone had recommended a leather shop, and it was on the same street as my family's old apartment, about halfway back to our hotel. Walking back along the Boulevard of King Alexandar, we stopped for espresso and ice cream on the way.

We sat and reminisced about what we had seen, found the leather store and my husband bought a European man bag.

The next day, we walked to the University of Belgrade, Medical Faculty campus. The main street led to the Clinic-A Internal Medicine building. I knew the building well. After all, I had attended lectures for six years at the amphitheater inside. As I stepped into the large room, the memories flooded me once again. I remembered the chalk as it broke in the hand of the professor or made an unpleasant screech on the blackboard. I could see the professor standing behind the large table with a long wooden pointer.

Webster took a picture of me sitting in the second row with a big smile on my face, the same seat that I was assigned half a century earlier. That girl had so many dreams, and now from the vantage point of years, I had a feeling of accomplishment. Still, even while sitting in the same seat where my life in medicine began, I could not explain to myself why I left. My only answer was that my need to go forward, to explore unknowns, was my life's destiny.

# CHAPTER FORTY-ONE

I LOOKED FORWARD to visiting with my dear friend Danka. She is married to Milenko and has two daughters, Vesna, and the younger, Maja. Danka and I became friends while we attended medical classes together. I hadn't seen her after I left for my internship in England. I had called her when I moved to Sweden, and we have continued our friendship through the years. We shared so many joyful memories. We were both searching for love, lust and later for jobs. We would reach out to each other by phone or letter.

Sadly, though, in 2016, when I called her hoping to have a nice, long conversation as we had many times before, she did not seem to remember me. Her husband came on the line and indicated that Danka was developing memory problems. I felt guilty for not visiting her before, and after fifty-two years, it was time for us to meet face-to-face once again. Now, when we were in Belgrade, we visited her home and were welcomed with love and many hugs. You could feel the family warmth. Maja spoke perfect English, and my husband commented on her skill.

"The only people I know with this vocabulary are English professors," he said.

"I am an English professor," she replied. That got a few laughs.

Maja was a lovely girl who was kind enough to chauffeur us about town. She told us about herself and her family. She discussed life growing up in Belgrade and during the Balkan war in the late nineties when NATO took action against the Milosevic regime. They could hear explosions in the city and one evening she went out onto her street and saw a Tomahawk missile searching for targets. Later she showed us the damage that remained from the precision strikes on military communication centers and the Chinese Embassy.

Danka and her family invited us to join them for dinner. Maja drove us to the restaurant where outside we met Danka's older daughter, Vesna, and Vuk, Vesna's twelve-year-old son. Vesna, who came directly from her work as a physical therapist, had a welcome embrace for both of us. Soon after, Milenko and Danka arrived. We all hugged and entered the restaurant together. You could feel how adoring both of the daughters and Milenko were of Danka. Her red hair was cut in an elegant style. She was fashionably dressed and looked younger than her age.

We walked to the dining room that was a glass covered garden. Our table was among old trees and illuminated by indirect lighting. Outside, we could see Tasmajdan Park, and looking up, we could see the high glass ceiling over the entire dining area, with night slowly approaching. We all sat down at our table, exchanged greetings and talked about our day. Then

my husband and I asked if Milenko would order, as we had discovered that you could request "off menu" if you were familiar with the restaurant. We started with a salad, and the waiters then brought plates piled high with a mixed grill of meats and vegetables. We ate family style, which we thoroughly enjoyed. Conversation was going on in both English and Serbian. Danka was having a good day and was able to participate in our conversations, and the hours passed quickly. A dessert was shared, and then Webster and I returned to our hotel. We stopped by the bar for a nightcap and to hold onto the wonderful feelings we had experienced with my friend from so long ago.

A few days later, we again met Danka and her family at a seafood restaurant on the bank of the Danube. A gentle breeze came from the water, slowly swaying the flower bushes that surrounded this lovely open-air restaurant. In the early evening light, we watched as boats and a few tankers passed by on the river. Danka spoke to me, "How nice to laugh again together, Tanya." Hopefully she was remembering some of our adventures from the past. There was a feeling of happiness and deep understanding, and at the end of the evening we had tears as we embraced. Separation is always difficult.

# CHAPTER FORTY-TWO

ONE AFTERNOON, MAJA drove us to Dedinje, which is considered one of the most beautiful and fashionable residential areas in Belgrade. We drove through forested roadways and up to higher elevations. Soon we realized we had arrived when we began to see the grand estates.

Dedinje was developed in the period between World Wars I and II. Luxurious villas with carefully manicured lush green lawns set back from the road are on every block. Today it is home to many of the diplomatic residences, as well as the United States embassy. We saw the stars-and-stripes quite unexpectedly in another country, reminding us of where we lived. Then we saw the White Palace (known in Serbian as Beli Dvor), which was originally the summer home of King Alexander I, Karadjordjevic.

After World War II, the White Palace became the residence of President Josip Broz, known as Tito, the leader of Yugoslavia. My mind went back to when I was a girl visiting the palace. I was a young *Pioneer*, dressed in my black school

uniform with a bright red neckerchief. I was selected to attend this special occasion because of my class scores, tops in all of the Republics. There were about thirty or forty of us honored that day. It was exciting, and led to one of the most embarrassing moments of my young life.

We had been invited to Tito's birthday celebration, and afterwards we were given a tour. We were taken to a large room with a long, beautifully decorated table. Refreshments were served: apples, bananas, grapes, strawberries, cakes and cookies. There were large pitchers of orange juice up and down the table, and somehow I spilled a full pitcher all over the tabletop! Every pair of eyes in the room turned and looked at me, and I wished I could simply disappear! Then a helpful man in a dark suit hurried toward me and cleaned up the orange juice before it dripped to the floor. President Tito addressed each of us, shook our hand and spoke a few words. A month later, a special postman brought a letter from the White Palace addressed to me. Inside was a picture of President Tito with his greetings written on the back, wishing me success in my studies. Thankfully, nothing was said about the spilled juice.

After we left the White Palace, Maja drove us farther south to Oplenac in Topola. After parking, we started up a path leading to the church on top of a high hill. The bright sunshine elevated our spirits while we climbed on that glorious day. Birds were flying around us as the fresh mountain air filled us with serenity and happiness. The path led us through a rich forest of oak trees, and I stopped several times looking at the different types of moss on nearby stones. I remember that when I went to

school, I used to love collecting moss and pressing it into a scrapbook along with flowers.

Topola is a town south of Belgrade, about a one-hour drive. In the early 19th century, King Karadjordje was born in Topola and was crowned in 1904, making Topola an important historic site. On top of a hill stands the church of St. George and the Karadjordje mausoleum. During WW II the royal family escaped through Europe to America where they were later buried after their life ended. In 2013, the remains of the Karadjordje royal family were moved and placed in a mausoleum on Oplenac. As we climbed the path upward, we could see the church with three domes and white marble walls, a beautiful contrast against the green of the grass, trees, and forest around us. Webster, Maja and I walked through the beautiful church portal and saw a large mosaic of St. George slaying the dragon. The saint's face was the face of King Karadjordje, a tribute to the liberator of the Serbian people. We saw the many intricate, beautifully restored, golden mosaic frescoes on the inner walls of the church.

Next, our guide suggested that we visit the museum dedicated to the Karadjordjevic family, at the foot of Oplenac hill in the town of Topola. On our return, we walked down the hill and into the museum at the bottom. The Karadjordje's cannon was at the entrance of the building—they forged the cannon in the eighteenth century. But they fired it only once to announce some important news to the people. Its right handle was removed and used as part of the crown of the new king,

Petar Karadjordjevic. I began to realize that my old country was finally able to embrace its beautiful history.

Maja went with us to a coffee shop on the other side of the highway overlooking a beautiful panorama of mountains, green fields, and vineyards in the distance. The day was full of peace and harmony as we enjoyed our coffee, talked and admired the beautiful countryside. No one would suspect we had not been friends for a long time.

# CHAPTER FORTY-THREE

W HEN MY HUSBAND and I visited our family's cemetery plot, we found that it needed new stonework. At the cemetery, we located a willing company that could do the work. When I ordered the granite, I found that approvals were needed from the city office that administers the cemetery. Over the years, Mama and I had made all the payments through friends in Belgrade—there never were any questions as long as payments were received. Mama was the responsible person of record for the plot, and she had passed away. There was no one to authorize the work, and they told us it would take months for the approvals. This was not good news. Fortunately, we knew Snezana, the sister-in-law of one of my hospital colleagues. She often visited her sister in Florida and had been at Mama's ninetieth birthday celebration. She worked for many years in Belgrade as a paralegal and knew how to get things done. She thought that the time required for approval was ridiculously long, and was certain she could help.

We went to the city cemetery's office, and they told her what was required to add my name to the official record. Then we headed outside where I hailed a taxi. Snezana gave the driver an address, and we went to see a lawyer in the city legal department to get the required paperwork. Catching another taxi, we went to a shop to get the documents filled out and notarized. It was happening so fast I couldn't follow everything. I could see some resistance to our efforts, yet Snezana was firm and calm; and the resistance crumbled. The whole project required a return trip to some of the previously visited bureaucrats. After a day of chasing paperwork, we made it back to the city cemetery department just before closing with the documentation. They said that approval would be ready the next day.

The next morning, we took boxes of chocolate and bottles of Scotch whiskey to the city office and picked up our permissions. Snezana made sure that everything was in order, and then she went with us to the granite company. She listed her name with the company as the one approving their final work as Webster and I would be back in the States before they finished. Her professional help was incredible, and now we could leave Belgrade with peace in our souls. She supervised the granite company after we left, and a month later she sent us a photo of the beautiful, finished work.

Several days after our bureaucratic whirlwind tour, we planned to meet Snezana and her family at Šaran, a fish restaurant beside the Danube. The hotel arranged a taxi for us, and we went to the river along a narrow road with restaurants and clubs on either side. Space was tight and cars parked in every

available spot of open ground. The taxi turned down a street next to Šaran and dropped us off at the restaurant. As we entered a cozy, elegant dining area, we were led to a reserved table. We were early and not long afterwards everyone arrived. Including us, there were seven around the table: Snezana and her husband, Kepa, their two children, a beautiful daughter named Milica and their son Marko, and her sister Vesna's son, Lazar, who was visiting Belgrade from Florida. During dinner, musicians serenaded us playing and singing Serbian folk music. We ordered off-menu, as we had become accustomed to doing by now, and the food was our favorite salad, *šopska salata*, a grilled seafood mix of fresh and saltwater fishes, *blitva* (Swiss chard), potatoes and roasted peppers served family style, followed by dessert with coffee and cordials. I remember that we all talked in two languages and laughed at Kepa's jokes. The conversation turned to Marko and his friend coming to the United States to work for the summer. They asked Webster about travel and geography in the States. Marko remembered his last trip to visit Snezana's sister in Florida and how he had gone out on our boat. Marko wanted to know if he could go with us on our boat again when he stopped in Florida to visit his aunt on the way back to Belgrade. "Yes, of course," we said. We made our farewells for the evening and gave our promises of where and when to meet again. The staff called a taxi for us, and we left by a very narrow street, the taxi brushing the mirror of one of the parked cars as it passed.

On our last day in Belgrade, we invited Snezana for dinner to say our thanks and goodbye. Red and pink flowers peeped

through the layers of greenery covering the ten-foot wall at the entrance to another open-air restaurant. There were white tablecloths and small flower arrangements on each table, and candles were lit to enhance the warm evening atmosphere. This elegant restaurant was a part of a "Club of Writers" in the center of Belgrade. When she arrived at the restaurant, we saw a beautiful woman with sparkling eyes and a kind smile on her face. Years had done little to change her appearance since we saw her about five years before in Florida when she visited her sister. The food was delicious, and the conversation flowed easily in English. We exchanged cell phone numbers and, after several hours, we parted as best friends. We will never forget her help and kindness.

# CHAPTER FORTY-FOUR

A MONTH BEFORE our trip to Belgrade, I had had a phone conversation with a friend from the past, Slobodan. He, like Danka, was my medical school classmate. It took a little bit of Internet searching, and then there he was, his picture, *curriculum vitae* and telephone number on the University of Belgrade website. I was surprised when he answered the phone himself, and he was equally surprised when he heard that it was me on the other end of the call.

"What happened to you after you left Belgrade?" he asked.

I began to tell him briefly about everything since we had been in classes together, but then stopped abruptly, realizing I could soon be speaking to him in person. "You know what? There is too much to tell you on the phone. Let's catch up in person."

Now, when we were in Belgrade, I called Slobodan from our hotel, and he had an evening planned for reconnecting. I could hear the tiniest bit of suspense in his voice. What had the passing of time brought? He and his wife made reservations so

we could get together for dinner; he gave us the name of the place where Webster and I were to meet them. Then, on a beautiful evening in Belgrade, we took a taxi to Kalimegdanska Terrace, a restaurant on the top of the medieval citadel overlooking the Danube and Sava rivers. The city skyline was behind us as we walked to the entrance, and the evening colors were a magnificent deep red, purple and yellow. The light from the sunset reflected off the ramparts and walls bathing us in a warm light. The restaurant was a perfect blend of modern and traditional, befitting the historic location. The menu was an impressive blend of French and Serbian cuisine.

We asked at the desk if our host had arrived, and they said he was already seated. The hostess led us back to our table. It is always an electric moment, that time when you reconnect with someone from many years past. Slobodan showed little of his age, except for his graying hair. He somehow seemed younger; even now there was that same familiar glint in his eye, that same smile on his face that I remembered.

"Finally, Tanya, we meet again!" he said.

"Finally!" I answered. I introduced my husband, and he introduced his lovely wife, Biljana.

The waiter came, but after quickly looking at the menu we suggested that Slobodan order for us. He asked if Serbian food and red wine were acceptable, and we enthusiastically said *da*, yes. The food was served, starting with Bulgarian salad, followed by mixed grilled meat, *čevapčiči* and *pljeskavice,* potatoes, grilled peppers and Serbian cheese. We had no room for dessert, just more wine. We settled into conversation in both Serbian

and English. Slobodan was a professor and forensic medicine pathologist. His wife, Biljana, was a pediatrician. She had been a few years behind us in medical school. He was her professor for a time. As he spoke, memories from the past flashed through my mind. I saw my friend as he had been more than fifty-two years ago, a young man with intense eyes and the energy and ambition of youth.

"Tanya, do you remember how we used to visit each other's homes and eagerly copy our medical class notes?" "Of course," I replied. In many advanced subjects there were no books, only the professor's lectures, so we took meticulous notes. We couldn't afford to miss even one minute of the professor's lectures.

"Do you remember," I continued, "how you used to joke with me about our last names?"

"Of course," he replied. "G comes before K, so when you got the highest score in the oral examinations, we victims after you needed to prove how much more knowledge we had. It was hard to compete with you." They had felt unfairly treated. At the same time, this competition pushed us all toward greater accomplishments.

As the night progressed, a feeling of mutual understanding came to all four of us. We talked about people we knew from the early 60s our colleagues, professors, and those who had since passed away. We casually mixed talk of our professional and private lives. Using the miracle of smartphones and the Internet, we were able to easily share our lives, pictures, adventures and professional achievements. Sometimes, one of us would start a sentence in one language, and the other would understand

immediately and finish it in another; this, between people who either had never met before or hadn't spoken to one another in half a century.

Something was extraordinary about that night. Adding to the magic was the Serbian music played by the local musicians. It fit with that special evening. So many years had passed; however, we didn't feel the distance. We had crossed the bridge of time, and when the evening ended after midnight, five hours after we began, we parted as closer than ever. Later, Webster told me, "I feel a connection with Slobodan. He is a friend." Fortunately, we were able to continue on another special evening.

One of the many favorite activities on our trip to Belgrade was sitting out beside the sidewalks at the coffee shops on the pedestrian mall, absorbing the sights, smells, sounds of the city, feeling the vibrancy of life and hearing the noise of a city center. Here, both Webster and I saw a deep passion for life. The enthusiasm, vitality and hope for the future we found all around was contagious, and we felt it, too.

In the evening, my husband and I often held hands and walked along the streets with the feeling of spring in the air. I always felt lighthearted after a long day of wonderful surprises from another deep journey through my past. I didn't need anything else, just to be outside, walking at a city pace, with a smile on my face. I said hello to random people as we passed, some of whom responded, some of whom didn't. My husband felt much the same. He quickly adjusted to the environment. Together, we were in full harmony with our surroundings in a vibrant and awakening city.

# CHAPTER FORTY-FIVE

B EFORE LEAVING HOME in Florida, we had carefully packed a portion of my Mama's ashes in a beautifully carved transport box. I wanted to place them in the Belgrade cemetery with my Papa's remains. My brother was at this cemetery two years earlier; he'd taken a photo we would use to guide us.

I could not bring myself to prepare Mama's remains, the ashes which we needed to reunite the family in the Belgrade cemetery. My husband packed the transporting vessel and required papers for the international flight. He had been rehearsing the steps in his mind and was able to get through this difficult task. It was hard for both of us, bringing the finality of everything back to raw reality.

As you might imagine, TSA has requirements that must be met to carry remains aboard. Our passage through airport security for the flight from Tampa to Zürich was quite out of the ordinary. The agents showed enormous respect as we declared what we were carrying. We were thankful as they

performed the safety measures while somberly showing an appreciation for our feelings. The transport box was then carefully encased in black velvet and repacked in my husband's roll-aboard bag, and stowed in the overhead compartment when we boarded the flight.

The gravity of the mission weighed heavily in the back of our minds, but we soon settled into the routine of the journey. In Switzerland, we had to change concourses and pass through security again, and when the item we were transporting was declared, the security agents were exceedingly respectful once again. Neither of us spoke German; however, as we passed through security, their kindness was expressed in a universal fashion.

We landed a short time later in Belgrade and exited the plane with our carry-ons, retrieved our checked bags and found our taxi, all without incident. We checked into the hotel and planned to complete our mission the next day.

After breakfast, we took a taxi and with us was our treasure. We gave our destination to the driver. We had a picture and the location of the grave: Parcel 8, lot 745. We searched, and the signs clearly showed Parcel 8. We walked past the hundreds of graves in the parcel without success. Then we asked for assistance. Finally, I showed some papers that I had, and they kindly pointed out that we were in the new cemetery; we were looking for the old cemetery. I bought flowers for the grave when we arrived at the new cemetery, so we boarded another taxi with the flowers in the cargo area and asked to go to the old cemetery, Staro Groblje.

At the entrance of Staro Groblje, we were told to go to a small chapel to wait and that someone would come to guide us. Comparing the trees in the picture with the trees we saw, we thought we were in the right area this time. Our guide arrived and took us on a winding trip up a rather steep hill to Papa's place of rest. We felt we were now making progress toward the fulfillment of our mission.

My husband and I approached the grave where my Papa and Noné Pina were buried together. The marble headstone was weatherworn with the passing of many years, yet the names were still legible. A cement cap covered the grave. Everything was serene, the sun was shining, the trees and grass were a vibrant green and a gentle breeze was blowing. This did little to give me peace. Thoughts of my loved ones flooded over me as I stood for some time, fixed to the spot.

Then Webster and I saw a hole had somehow opened in the middle of the cement covering the grave, big enough for a hand to fit inside. We stood for a while, trying to understand what had happened and finally accepted that which unseen forces had given to us. Webster spread Mama's ashes in the hole, down upon the earth covering Papa and Noné Pina. I covered the opening with the large evergreen wreath with red flowers I had carried in my arms. I stood there for a time, crushed by the gravity of the moment. I will never know if the universe prepared the grave for me to return with Mama's ashes, joining them forever with Papa and Noné Pina. The opening was not there before when Mirko took the picture we had to guide us.

To complete our task, the grave needed to be sealed and the weathered marble replaced. I ordered a beautiful grave cap and headstone of red granite with gold engraving. The memorial was completed with two lovely granite vases of the same stone, commemorating the final joining of my loved ones. It would be installed after we returned home.

We stood for a while, looking out over the horizon toward the city, praying and remembering. We held each other tightly as we touched and placed kisses on the old, weathered marble stone and inscribed names.

Then we went down the hill, turning onto the paved path, walking past the chapel and out the gates where we had entered with thoughts spinning in our heads as we left the serenity of Staro Groblje and returned to the reality of the city streets.

# CHAPTER FORTY-SIX

I HAD MADE the journey to Belgrade to rediscover my childhood. Paradoxically, I couldn't. Everything, as I had remembered it, was changed, and most likely had changed a long time ago. Along the way, I realized that it was unrealistic to search for visions of my childhood world that had passed by so quickly. This journey nonetheless was important to me. I learned that the spirit inside me—the one that leads us to happiness and contentment—will not grow old if it is sufficiently nourished.

I regard all such moments as gifts whether they reveal something good or something bad. Maybe, the reason I can view them this way is that I've realized most of my old dreams. Discovering myself along the way was often a painful process, albeit, strengthening me. I hope to share my stories with as many people as possible. This way, some might discover themselves as well their own spirituality. They may find some comfort and enjoyment.

Looking back, I realize how visiting my family's final resting place gave me closure and helped to heal the spiritual wounds that had been open for such a long time. It's true that no serenity, no sunshine, no birds chirping in the trees could alleviate the deep pain I felt while saying goodbye. However, I do remember one moment quite clearly, which was my last moment in the cemetery. Webster and I were standing on the hill near the grave, watching the sun vanish behind the white clouds on the horizon. With a kiss on my fingers, I touched the gravestone, then turned and left when Mama's words came back to me: "Turn the page and go forward."

> *Let me be free*
> *from my past bonds*
> *holding me tight.*
>
> *In the freedom of the new light,*
> *slowly engulfing me*
> *in the dawn of the simple life.*
> *Let my soul not fight.*
>
> *Let me dust off memories*
> *building castles of my dreams*
> *that mercifully draw me back.*
>
> *Now I am here with a fire,*
> *now I am here with rain drops desire,*
> *to look through to the sunshine*
> *to visit a girl's secret house,*

*with dreams entering into my soul*
*after my leaps and fall.*
*Take away my fear,*
*I am now boundless,*
*in the sunset of the red sky,*
*delight in the new path,*
*let my soul fly.*

Tatjana Webster, St. Petersburg
November 2017

# EPILOGUE, 2018

THE CIRCLE OF Mama's last travels around the world is closed, part of her now rests in Sweden where my family lives, a part in Belgrade where Papa and Noné Pina found their eternal peace, a part in Split where she was born and here in Florida where I live.

In May 2018, my husband and I were visiting Belgrade and took a short flight to Split, with our hearts full of bittersweet pain, knowing Mama's love for her birthplace and how she came to life when we had visited before. Somehow, we knew the trip would close a wound open for some time. One evening, my husband and I slowly walked on the shore of Bacvice, Mama's favorite bathing place. I was holding a small carved wooden box with Mama's last remains.

It was a beautiful evening with the sky changing colors. We watched lilac, pink and golden light in the sky among the white clouds. I was able to hear the gentle rustling of palm branches in the breeze. I saw a few seagulls, but I couldn't hear birds

chirping. Silence was somehow folded in with the beauty and somber feeling around us.

We found the place on the walkway where Mama would jump into the sea. We both had in our minds a picture of her happy face when she came up the ladder, dripping salt water with joy in her eyes.

Then, we came to a secluded area, and I sat on the steps going down into the sea. There was open water between us and Mama's favorite place to swim. My husband who was sitting behind me had his supportive hand on my shoulder. With deep, overwhelming pain in my heart, I opened the beautiful box and let the last atoms of her join the slow rolling waves of the deep blue sea. At that moment I knew that the Universe would help me to find some peace in my soul.

We both prayed and cried with the remembrance of her life, but somehow, we also felt a slow closure of an era. Knowing our mission, Mirko sent a message from Sweden to my phone that he was thinking of us and sending prayers. Every time we see the sea, no matter where in the world we may be, we will feel Mama's presence, Mama's guiding spirit intertwined with my soul. I felt that I was on the threshold of a door leading to another unknown leap and that I had to go forward.

## LAST EVENING

*Engulfed by serenity,*
*we watched sky; pink, lilac and pale,*
*drawn by evenings colors,*
*covering nature and us with the magic veil.*

*Birds hidden in the tree,*
*slow rolling waves of Adriatic,*
*waiting for the last atoms of your being,*
*joining forever your beloved sea.*

*Unbearable pain in my heart,*
*tearing my soul apart,*
*approaching the place of your rest forever*
*with universe, body and soul,*
*while slow waves take my treasure,*
*light as a feather.*

*May you have ultimate peace*
*leaving in daughter's heart a big hole,*
*to be filled with your love,*
*wishing you peace forever.*

Tatjana Webster, Split
May 2017

# POSTSCRIPT

WRITING ABOUT MY life has taken me on another leap, this time into my past. I learned more about my Lukić family and their escape from Split, one family first traveling to the Syrian camp El Shatt, and after the war emigrating to South America, never to return. Cousin Arsen and his family fled to a refugee camp at Puglia in the south of Italy. When the Allies took control of the area, they were given jobs at the U.S. base and life improved. Arsen says that a U.S. Army officer, from Manchester, Massachusetts, befriended him because he looked like the officer's brother who was killed in the Pacific and he often talks about the U.S. Army Officer's kindness. This part of my Noné Pina's husband's family returned to Split a few years after the war ended. I wish they had written down more about their travels and hardships during this time, and yet, I feel hesitant to ask, as some of the memories might be difficult and painful.

Information about Papa's family is lost. He was estranged from his family when he chose a career in the military over the

family business. He further alienated them by marrying outside their religion, and then added to the conflict by moving to Belgrade.

I recently discovered a "Gossip Column" article reporting on my Palm Springs visit with my medical school classmate: *The Desert Sun, Palm Springs, Calif—Friday, September 4, 1981—D10.* My friend included the clipping on his website, in his memories section, and it is now in my story of memories.

Lastly, this experience has been both enlightening and cleansing. It has given me an outlet for my sorrow and pain after losing Noné Pina, Papa and Mama. Writing about my return to Belgrade put to rest old ghosts and gave me new directions for the future, and it has given me new insight and appreciation for all of the kindnesses shown to me in my life.

Now it is time for new dreams and leaps.

Thank you one and all.

# PHOTO GALLERY

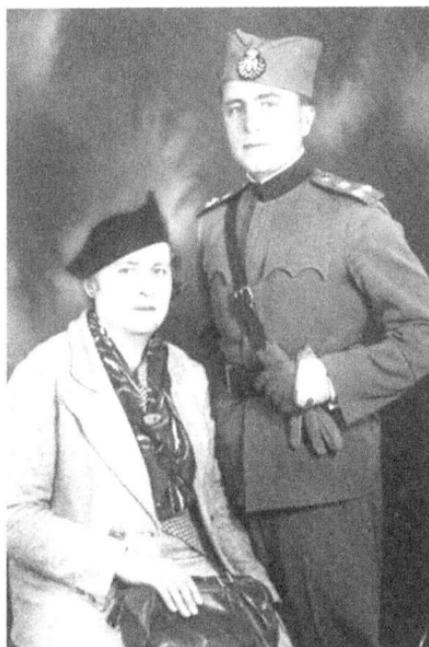

*Papa with his mother, early 1930s.*

*Noné looks fashionable at young age of about 25, Dubrovnik.*

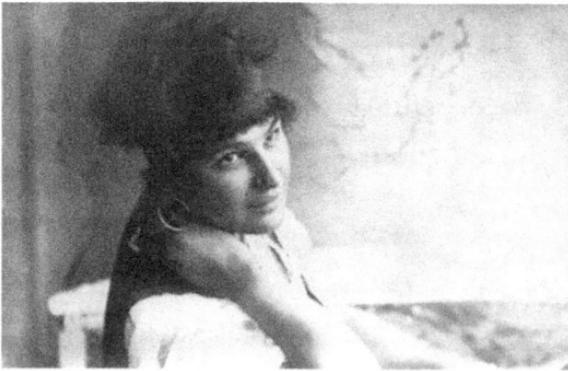

*Noné Pina was a fashionable lady: 1930s.*

*Mama's father Miro, 1935.*

*Papa on his horse holding the flag with Badnjak on the back of his saddle: Christmas celebration in Split, Dalmatia, 1937.*

*Papa enjoyed photography and took this picture of his love with the Riva in the background that has changed little over the years. Remarkably, it looks the same to this day: Adriatic Sea port of Split, 1939.*

*Papa on military exercises in Skoplje, Macedonia: Christmas 1940.*

*Papa, a Calvary officer on his horse, around 1940 in Split.*

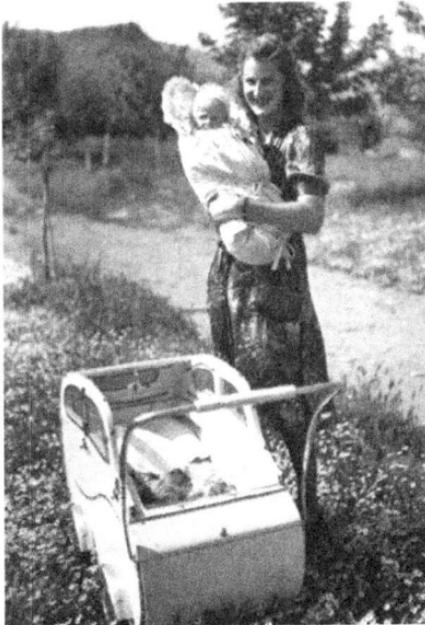

*Mama with new born baby Tanya: 1943.*

*In early spring with snow covering the ground, Papa is holding Tanya who is proudly holding her doll: Bulgaria 1945.*

*I am about 3 years old with my doll: Sofia, Bulgaria.*

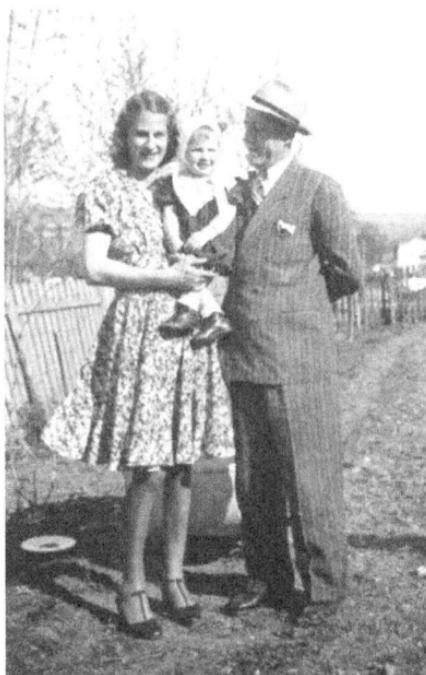

*Papa called me "Zeko" (Rabbit) because of my baby cap with "ears":*
*Bulgaria, 1945.*

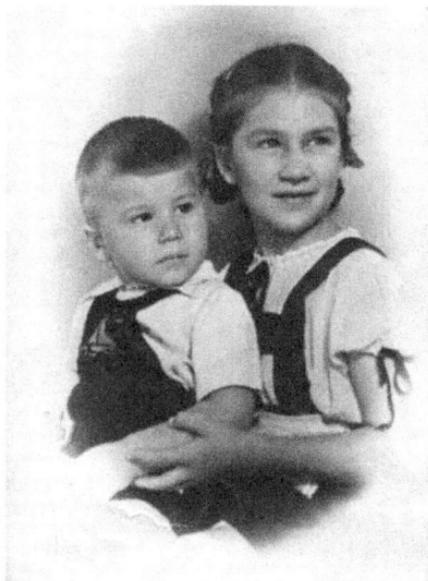

*My brother Mirko and me, in early 1950s: Belgrade, Yugoslavia.*

*Mama, Mirko and me in the spring, in the park in Belgrade, enjoying sunny day; early 1950s.*

*Papa and brother Mirko , mid 1950s in Belgrade, Yugoslavia.*

*Papa and Mama at home, in Belgrade in late 1950s in living room.*

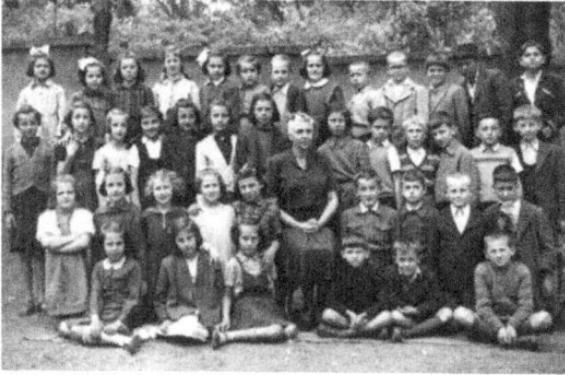

*My class of 1952, Belgrade. I am 4th in the second row from the left.*

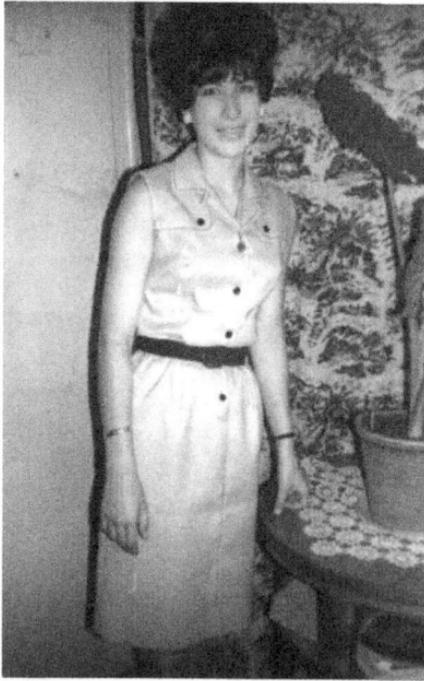

*While living in England, I was able to buy a new blue dress: 1967.*

*Sitting in my office when I was an Internal Medicine Doctor at Linköping University Hospital: Summer in early 1970s.*

*My invitation to the International congress in New Delhi, India: November 1976.*

*Other side of Indira Gandhi's invitation in the language of India.*

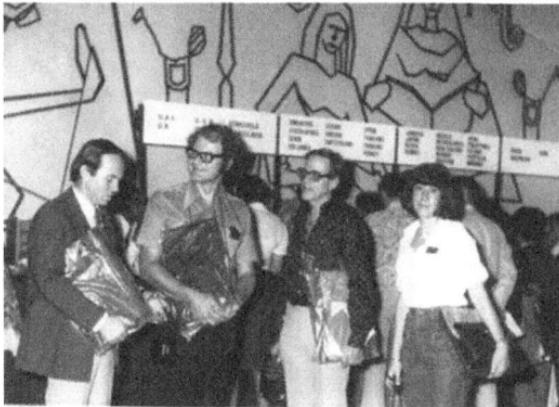

*Swedish group ready to enter the International conference in New Delhi: November 1976.*

*Standing on the lower plateau of the Himalayas, early in the morning before flying around Mount Everest: Nepal, 1976.*

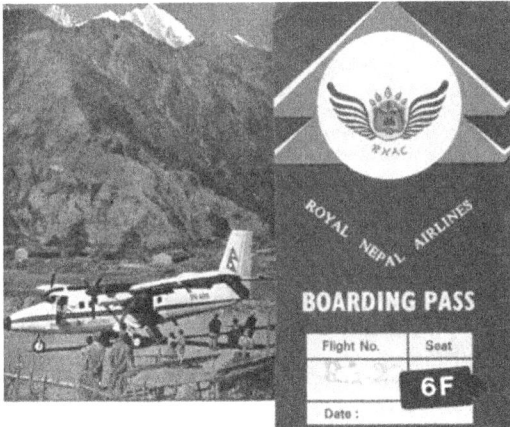

*My boarding pass to fly around Mount Everest, oxygen masks were provided: 1976.*

*I am walking on streets on Kathmandu, Nepal,
1976 enjoying a mystery of a very old culture.*

*I took a picture of our tour group at Mahatma Gandhi's tomb: 1976.*

*Exploring the mysteries of India while walking on the streets of New Delhi: November 1976.*

*Our group from Sweden, ready to go to the party at Indira Gandhi's Residence: New Delhi 1976.*

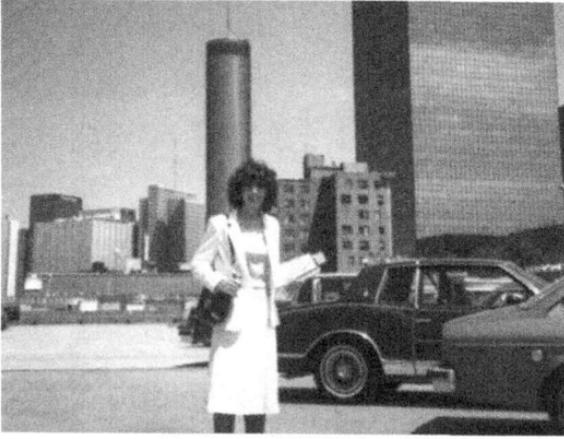

*I am ready for my presentation in Atlanta: Early 1980s.*

*In 1981, I was invited to Palm Springs, California to visit my school mate from Belgrade who became a successful plastic surgeon.*

*Internal Medicine/Nephrology specialists, University of Florida, Gainesville: 1985.*
*I am in top row 1st from the left.*

*In 2008 I made a return visit to Karolinska Hospital where I began my medical career in Sweden.*

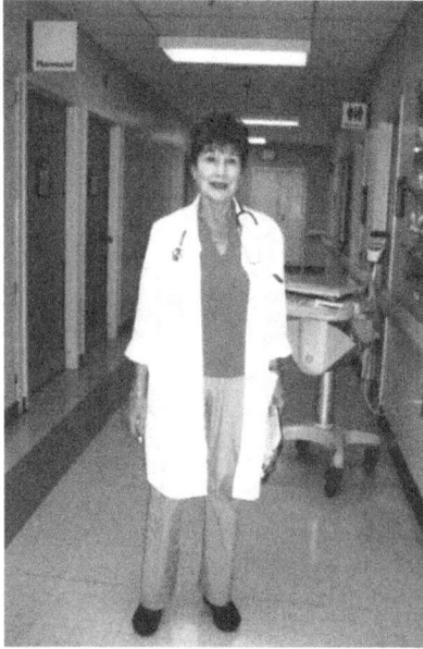

*Starting my medical rounds at the VA Hospital:*
*St Petersburg, Florida, 2012.*

*Me in my office at VAMC Bay Pines.*

*Mama at age 91: St Petersburg, Florida.*

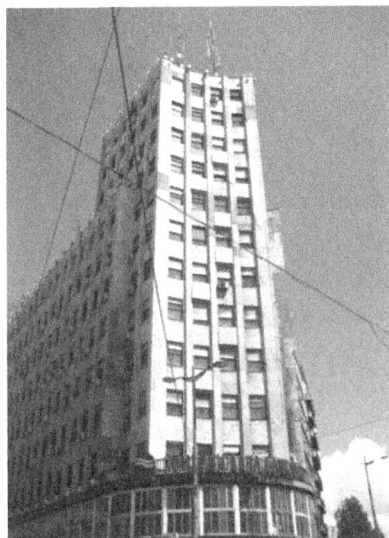

*Mama worked 25 years in this Belgrade building we called "skyscraper."*

*The amphitheater at the University of Belgrade where I sat for classes in the 6 years during my medical studies: 2017.*

*Photo was taken from Banner at Etnografski museum in Belgrade, and represents country dance called folklor with people dressed in special outfits. Children hold their hands and dance in circles followed by folk music.*

# ABOUT THE AUTHOR

Dr. Tatjana Webster was born in Yugoslavia, graduated from University of Belgrade Medical School and completed her internship in England. She then took a position as a medical doctor in Sweden, specializing in Internal Medicine and Nephrology. After achieving success in her medical career in Sweden, her burning desire for research, which began in England, led her to the United States. After her research fellowship in the US, she qualified to become a medical doctor in Florida and continued a successful career there until she retired. She and her husband have lived for 30 years in St Pete Beach, on Florida's West Coast.

Made in United States
North Haven, CT
03 August 2023